LIVERPOOL THROUGH THE LENS

LIVERPOOL THROUGH THE LENS:

PHOTOGRAPHS BY CHAMBRÉ HARDMAN

 THE NATIONAL TRUST

Acknowledgements

Edward Chambre Hardman Trust: Peter Hagerty, Chair; Peter Booth; Norman Dalziel; Michael Dunn; Colin Ford; Anne Gleave; Paul Goodman; Mike McCartney; Phillip Plant; Bob Pointing; Roger Prideaux; Peter Sills; Merilyn Smith; Dorothy Taylor; Vivienne Tyler; Edward Woolf.

Grant Berry, Emily Burningham, Simon Osborne, David Porter, Vicky Skeet, Heritage Lottery Fund, Liverpool City Council

First published in the United Kingdom in 2007 by
National Trust Books
10 Southcombe Street
London
W14 0RA

An imprint of Anova Books Company Ltd.

Captions written by Joseph Sharples

Copyright © 2007 National Trust Books
Designed by Lee-May Lim
Typeset by Vicky McFarlane

ISBN 9781905400546

A CIP record for this book is available from the British Library.

Printed and bound by Craft Print International Ltd, Singapore
Colour reproduction by Spectrum Colour, Suffolk

15 14 13 12 11 10 09 08 07
10 9 8 7 6 5 4 3 2 1

This book can be ordered direct from the publisher.
Please contact the marketing department.
But try your bookshop first.

CONTENTS

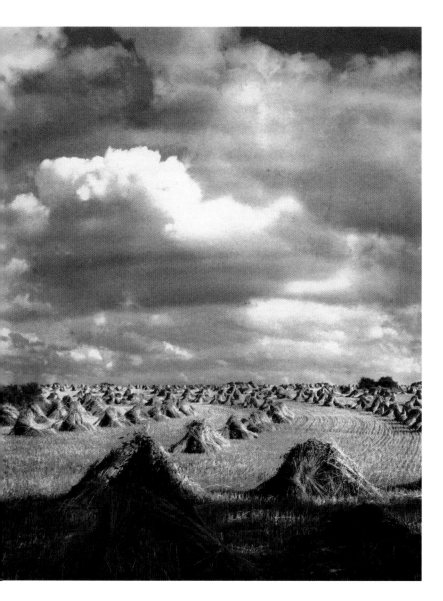

In 1988, Viv Tyler, a longtime friend and colleague, started one of her many subsequent phone calls to my Wirral home with, 'You like photography, don't you?'

'No,' I replied, 'I love photography, always have, always will.'

'Well, you'd love the Rodney Street house I'm working in, it's the home of E. Chambré Hardman . . . you must see his photography.'

Initially, the idea of a photographer's studio in the Harley Street of Liverpool was not top of my pops . . . far too posh for a working class lad like me. My family could only just afford the chemist prints for our Brownie Box Camera, never mind professional portraits, and anyway I was too busy. But, over several months, Viv eventually wore me down and I agreed to visit . . . 'and wear your old clothes,' she added, 'It's very dusty.'

On entering 59 Rodney Street, it wasn't the posh old dusty home, or the classy portraits scattered round the ground floor which sealed my fate, it was walking up the staircase to the rest of the magic time warp when I spotted E. Chambré's . . .'clouds'. . .

I've seen clouds in real life and in photographs all my life, but none so breathtaking or as real as the Master's . . . so I stopped.

I've found over my 60-odd years, one of the answers to life is . . . if you stop, i.e. when a different song comes on the radio and you stop to listen, or your first chip butty, which you stop to taste.

Chambré's clouds took me back to New York in the 60s. Scaffold and I were leaving the Peggy Guggenheim Museum after visiting the latest, trendy Claes Oldenberg 'soft sculpture' exhibition, when I spotted a fascinating, black and white exhibition by a photographer called 'Bill Brandt' and stopped, and was hooked . . . just like with Chambré's clouds.

Continuing up the Rodney Street stairs, I entered a world of cupboards containing untouched, two-inch-thick dust on tins of Heinz Baked Beans, cocoa, and even Ribena! All with their original 1920/30s labels . . . plus drawers full of 'Pilot' matches which Edward had stored like a squirrel (like me!) for so many years . . . you could monitor the changes in the pilot's sou'wester! . . . old classic radios collected, but then sold when business was slow, or when portraits had become a luxury . . . rooms with poisonous chemicals (to print his clouds), and at the top of the stairs, his and wife Margaret's sit-up-and-beg bikes, resting together like well-travelled lovers.

This first visit saw me trapped in ECH's dusty time machine, and each subsequent trip saw the opening (like presents) of different white boxes containing prints of countryside clouds, portraits, snow scenes, and even India, where he'd served in the army . . . the majority taken before I was even born.

Weeks turned into months, into years, with stories slowly emerging of this hard-working, loving, eccentric couple. Stories like Edward and Margaret riding their bikes to Lime Street Station, boarding steam trains bound for the Lakes or Scotland, and on arrival, at the start of their hot, photographic day, digging deep holes under shady trees, and burying their hard-boiled eggs, to keep them cool till lunchtime!

To preserve these stories, the house and Edward's remarkable collection, a group of voluntary trustees assembled and after many hard-working, roller-coaster years, trying to save 59 Rodney Street, Viv, Pete, Edwin, Norm, Roger, Mike, Merilyn, Colin, Peter, me, etc, eventually handed over the reins to the ones best suited for ECH's future . . . the National Trust. In fact, without those dedicated trustees, I'm sure 59 Rodney Street would have slipped away from us my hats off to them.

But don't let my mere words influence you . . . come to the magic house to see for yourself, and please, let us know what you think.

A landscape photograph showing corn stooks stretching out into the distance and featuring the distinctive 'Chambré Hardman clouds' which so entranced Mike McCartney.

Every city has a renowned portrait photographer and for Liverpool it is Edward Fitzmaurice Chambré Hardman. But it is less common that the photographer should also be a great landscape photographer and one who would create a photographic portrait of the city and its citizens and then leave it to them as a legacy. My first meeting with Hardman was a chance occurrence in which a shared love of photography brought us together, and in quite different ways left its mark on us both, By birth Hardman was an Irish photographer born in Fox Rock, County Dublin in 1898 and he learned the rudiments of photography from his father but there was no thought that this might be a possible career; his parents were intent that Chambré Hardman should accept a commission as a Regular Officer in the Gurkha Rifles. It was while serving on the Khyber Pass that Hardman became friends with a fellow officer, Captain Kenneth Burrell. Discovering a shared interest in photography, the pair agreed that upon leaving India they would return to Burrell's home town of Liverpool and establish a photographic studio.

At this time Liverpool already had any number of portrait studio photographers competing for work but by 1923 the 'Burrell & Hardman' studio at 51a Bold Street was also open for business. Financially, the early years were difficult but Burrell used his family connections to advantage, and Hardman's membership of the Sandon Studio Society at Bluecoat Chambers gradually brought an increasing number of sitters and satisfied clients. There was also time for Hardman to experiment and by 1925 he had become a member of the Royal Photographic Society (RPS) where he showed exhibition standard prints at the Society's annual exhibitions. While the Burrell & Hardman studio specialised in portraits, increasingly photographing architecture became part of Hardman's professional portfolio – during this period he photographed many of Liverpool's great buildings as well as shipping scenes and the Mersey docks.

Around this time, Burrell appears to have lost interest in the business and he left Liverpool to pursue alternative careers. However, a new and more important person came into Hardman's life at this time when a Liverpool student called Margaret Mills came to work as a photographic assistant in the Bold Street studio. Their shared passion for photography made them a natural team, and while the early years of their relationship were turbulent, by 1932 'Gobbles and Pearl', as the couple affectionately called each other, had married.

The economic conditions of the 1930s made life difficult for the couple, but Hardman's growing prestige and their recognition as Liverpool's photographers of choice meant that by 1938 they were able to open a second studio in St Werburgh Street, Chester, some twenty miles from Liverpool. Hardman would commute twice weekly to take portraits and then bring the negatives back to the Bold Street studio in Liverpool for processing and printing. The hard work in building up the small studios culminated in 1948 when the Hardmans felt confident enough to move their home and studio to new and larger premises at 59 Rodney Street, a prestigious Georgian terrace adjacent to Liverpool's Anglican cathedral.

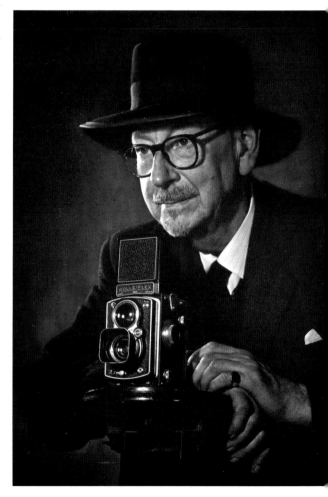

Edward Chambré Hardman in 1969 with the Rolleiflex camera he used to take many of his most famous photographs.

Business was now at its peak and required a staff of five full-time employees and a number of part-timers. Professional recognition from his peers came in Hardman's election as a Fellow of the Royal Photographic Society (FRPS) and his being voted First President of the West Lancashire and Cheshire Institute of British Photographers. Of course, the real success story of the Burrell & Hardman studio was the joint achievement of Mr and Mrs Hardman: 'I could not have done it without her,' Hardman once remarked when describing their working partnership, in which Margaret would concern herself with the staff and the efficient running of the studio business and darkrooms, while he, with a mixture of flattery and charm, would negotiate the personality of the sitter in an endeavour to make a good portrait likeness.

Today, snapshots and family photography using small cameras has replaced the formal studio portrait, but during the 20s, 30s and 40s, the clients visiting a professional studio to have their portrait taken were the mainstay of the business. The importance of having a portrait made of a loved one also gained an added dimension during the 1939-45 war, when the work of portrait photographers and their trained staff were considered 'reserve occupations' – jobs which made a valuable contribution to the war effort. A photograph of a loved one was a reminder to those left at home of those who had gone away to fight, and sometimes became their only memorial.

More commonly, a sitter would require a portrait for professional use, or perhaps to celebrate an engagement, a wedding or a child's coming of age. However, for many the very thought of having to sit for a studio portrait photograph held as much fear as the prospect of a visit to the dentist – or even worse, some would suggest. Margaret would endeavour to make the experience as pleasant as possible, allowing

Margaret, Chambré Hardman's wife, posed for this photograph entitled 'The Diver' and dated 1929..

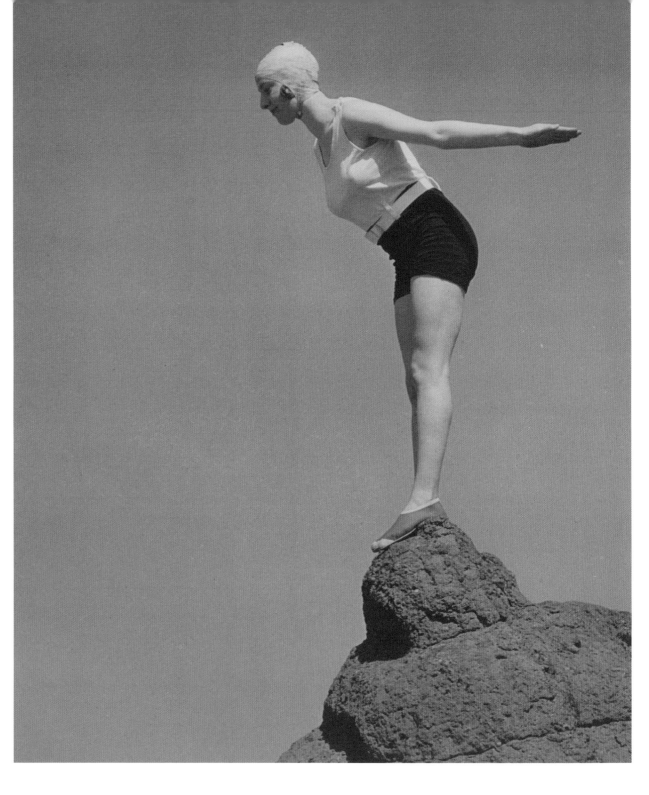

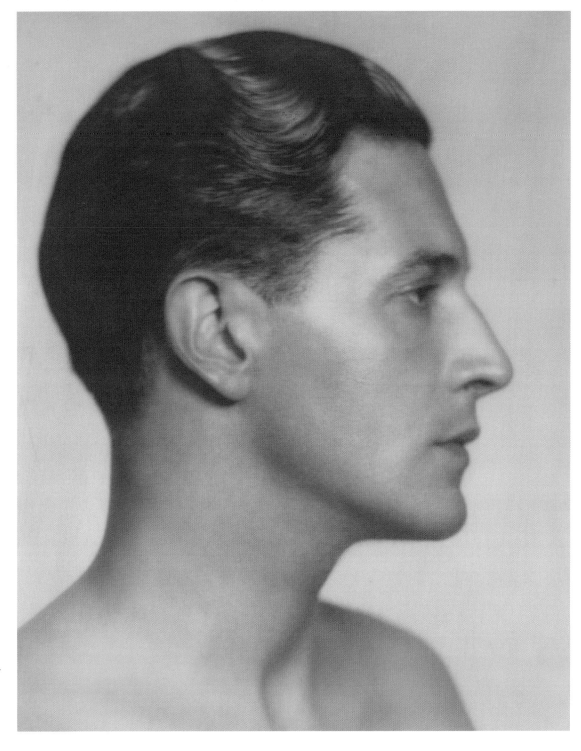

A portrait of Ivor Novello, taken by Chambré Hardman in 1929.

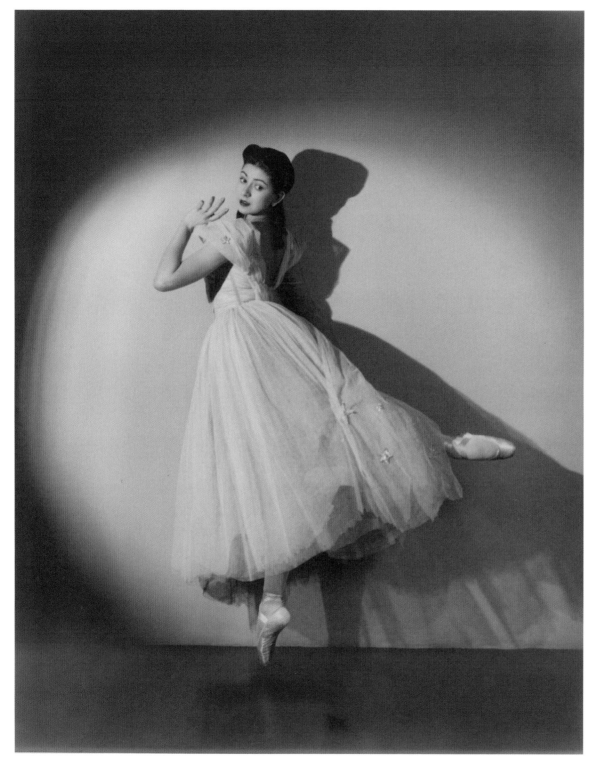

customers to relax in the comfortable front room at No 59 before showing them to a dressing room and offering them tea. For the many professional actors who visited the studio, the process could be quite different; their familiarity with the camera and their conscious knowledge of their best aspect often had the photographer beholden to the star. The singer Ivor Novello was famous in this respect, demanding that 'only the right-hand side of my face be photographed'. Another new and commercially rewarding business developed when Hardman undertook taking publicity stills of theatre performances at Liverpool's Playhouse and other theatres. Sometimes, as in the case of the elegantly posed Margot Fonteyn, portraits were taken on location at very short notice.

Portrait photography was the Hardmans' bread and butter which, perhaps, reflects the fact that when photography was first revealed in 1839 to the public of Paris, the first commercial use was in making portrait photographs. However a second use – photographing scenic views and the natural landscape – also became popular. While landscapes were less financially rewarding than portraits, photographers soon began to make portraits for profit and landscapes for pleasure and to demonstrate their artistic credentials. By the beginning of the 20th century, landscape photography dominated the competitive amateur exhibitions and professional salons throughout Europe and America. From the 1920s onwards, Hardman was a frequent exhibitor at annual exhibitions, including the Royal Photographic Society and also the independent London Salons. Hardman also achieved a notable success in 1927, winning first prize in the American Annual of Photography Exhibition for his picture of the sleepy French fishing village, 'Martigues'. This was one of the many photographs Hardman took in France during 1926, along with the very popular and romantic 'A Memory of Avignon', which described in softened focus the delightful ambience of a street café where his friends were relaxing after lunch.

The ballerina Margot Fonteyn, in an elegant pose captured by Chambré Hardman in 1939.

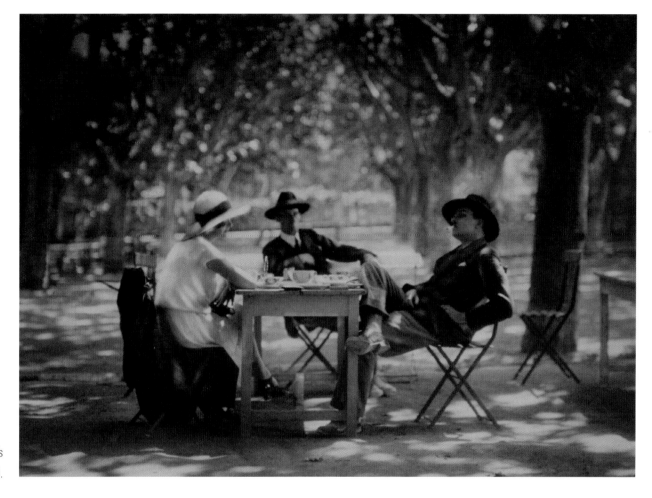

'A Memory of Avignon', 1926: A group of Chambré Hardman's friends relax after lunch at a French street café.

During the 1930s, when taking time off from the busy portrait studio, Hardman and Margaret would spend their weekends and holidays exploring the British countryside. Using trains and bicycles they appear to have travelled the length and breadth of Britain in their search for new landscape photographs. The black and white photographs from this decade have a sharper focus, stronger contrast and are often notable for the dramatic mountain landscapes such as the elegant formal description of trees and clouds in 'The Copse, Galloway' (1935) and the dark brooding landscape of 'Loch Alshe and Sky' (c. 1948 – see the following page). Frequently, inclement weather brings out the best view of a landscape for photography, a subject Hardman was happy to advise upon in the magazine articles he wrote with titles such as: 'Commanding Artistic Control' or 'Exhibition Quality, Some Ways of Attaining It'.

Perhaps Hardman's photograph, 'The Birth of the Ark Royal' (1950) is his most famous picture. It is certainly the most written about, and usually because it brings to the fore the contentious question of whether photographs should be retouched. Of course, portrait negatives have always been retouched, as it is part of the process of flattering the sitter, but what about documentary or historical subjects? On one particular day in 1950, the view from Holt Hill looking towards the Birkenhead docks on the River Mersey was to Chambré Hardman's eye, spectacular. The recently completed aircraft carrier Ark Royal, with a fresh coat of white paint, stood ready for launch by the Queen Mother; the great vessel appeared to float above the city of its birth, and if ever an image summarised the wealth of a city created by shipping it was this.

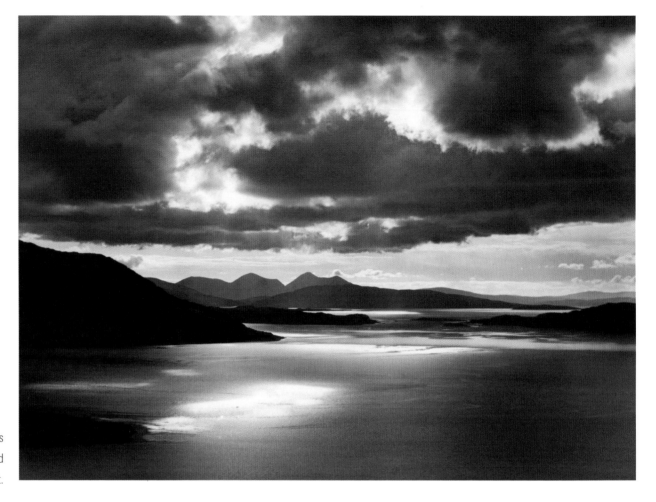

'Loch Alsh and Skye', 1935: This dark, brooding landscape was photographed by Chambré Hardman while travelling in Scotland with Margaret.

But to Hardman's critical and artistic eye, the scene still lacked something, so a young boy was drafted in, bribed with a small coin and asked to walk down the road following the kerb, while Hardman carefully composed the scene on the ground glass of his Graflex camera. It looked like a perfect pictorial composition, but when the processed negative was later viewed in the dark room, the tonal balance was all wrong. Hardman remarked: '...when I looked at my negative, that white-washed gable end [the house nearest the camera] was a severe snag. It threw everything out, you see. I was trying to produce an effect and anything that goes against the effect I want, I rule out...' Earlier in his career, Hardman had learned how to use enlarged negatives in the making of carbon and bromoil prints and now, decades later, he would use this knowledge to remove the offending intrusion by retouching the negative, using red dye. His desired effect was achieved and, while we can see that the historical truth has been altered, the result is a photographic masterpiece (see page 92).

Throughout the 1940s and 50s Burrell & Hardman were recognised as Liverpool's photographers of choice and, with their large staff of darkroom assistants, their business was a model of success. However, the post-war era and the decline of Liverpool as a port had a slow but inevitable effect on the economy of the city and also on the studio business. In 1965, Hardman retired from professional photography and he and Margaret prepared for a more leisurely lifestyle devoted to personal photography. Sadly, her tragic early death from cancer in 1970 left Chambré without Pearl, his closest friend and professional colleague.

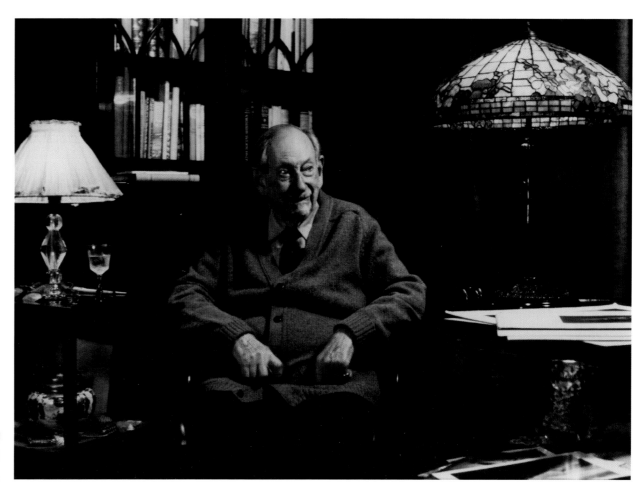

Chambré Hardman photographed in the Waiting Room at 59 Rodney Street by John McDonald (c. 1987).

Now living alone in his large Rodney Street studio and home, Hardman continued to submit work to annual exhibitions but his increasing frailty made climbing the many stairs difficult and, inevitably, one day he suffered a fall. At the time, I was running the Liverpool Open Eye Photography Gallery and a perceptive social worker contacted me regarding Mr Hardman's plight. What a revelation awaited me when I visited him – his home and studio were filled with examples of early 20th century photography – an entire collection of photographic prints, negatives, cameras, lights, darkroom equipment, letters and studio records. Although much neglected – a number of ceilings had collapsed in the intervening years – every room was crammed with photographs and ephemera, complemented by the more domestic scenes in the two rooms and small kitchen where Hardman and Margaret had lived.

During the subsequent ten years of our friendship until his death in 1988, it was clear to me that his work must be protected, and while Chambré had no living relatives to assist, friends and supporters came together to form the E.Chambré Hardman Trust. During the following years the trustees worked to secure funding and support from English Heritage and Liverpool City Council, which allowed essential repairs and a conservation programme to begin; to date more than 12,000 photographs have been catalogued. Meanwhile, the Liverpool public were introduced to Hardman's photographs by the first retrospective exhibition of his work, which was shown at the Open Eye Gallery, Liverpool in 1980, followed by a major exhibition: 'E. Chambré Hardman Photographs 1921-72' organised jointly by the Walker Art Gallery, National Museums Liverpool and the National Museum of Film Photography and Television, Bradford, in 1994.

Subsequently national newspapers and magazine features highlighted the value of the collection, but it was not until 2003 when the National Trust took over the administration of the house and opened it to the public that Hardman's legacy was secure. Looking back over the twenty years since I sat with Chambré Hardman in his tiny kitchen and recommended that he must establish a Trust to protect and conserve his work, I would like to think that he would be pleased at what has been accomplished.

Dr. Peter Hagerty
Chair, Chambré Hardman Trust

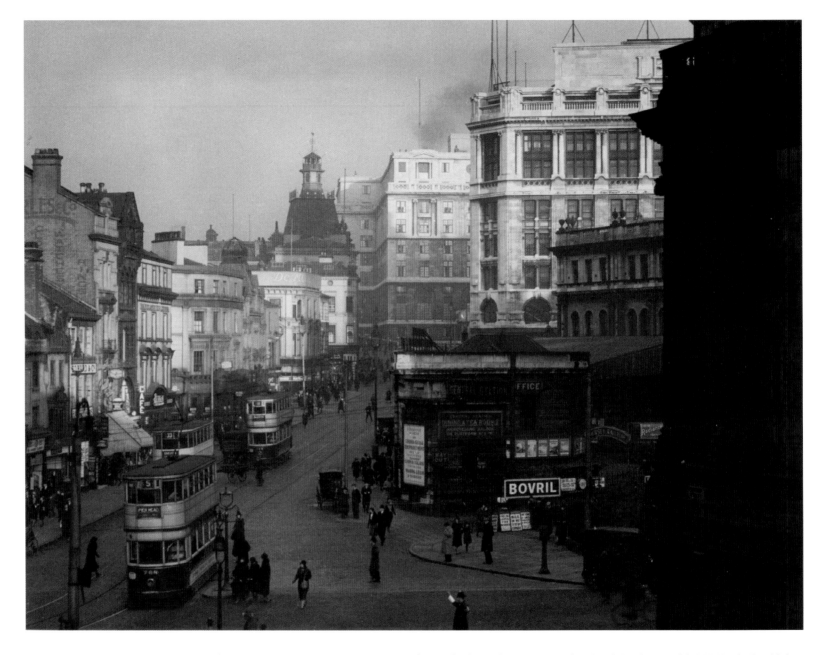

RANELAGH STREET

In the foreground is the rather untidy entrance to Central Station, including the underground Mersey Railway. More impressive is the tall, white building just behind. This is Lewis's giant department store, as rebuilt in 1910–23 by the architect Gerald de Courcy Fraser. It was bombed during the May blitz of 1941 and rebuilt yet again by Fraser after the War. Beyond it, closing the view up Ranelagh Street, is the elegant façade of the famous Adelphi Hotel, the third to occupy the site. Dating from 1911–14, its refined interior matched the sophisticated glamour of the transatlantic liners that sailed from Liverpool, and it offered its guests the same level of luxury.

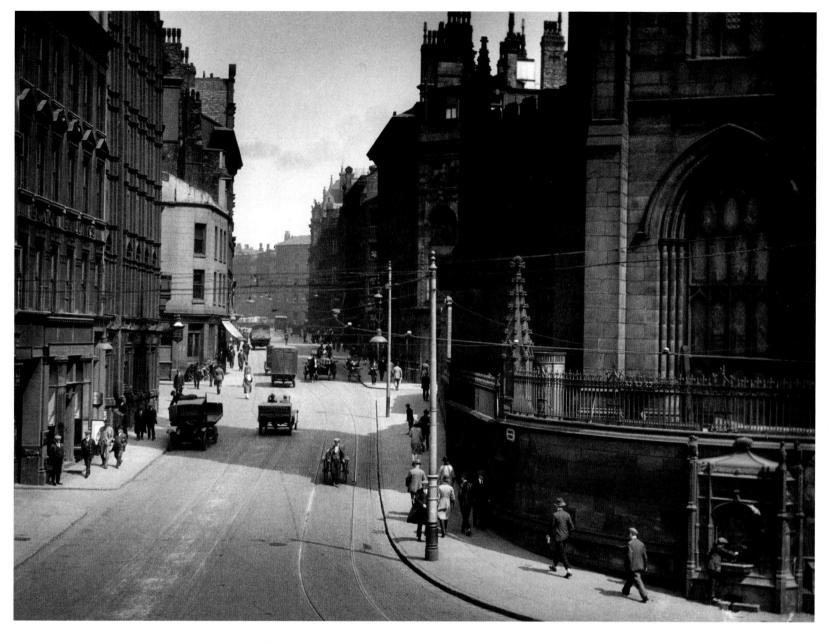

CHAPEL STREET
PRE-1957

At the foot of Chapel Street stands the church of Our Lady and St Nicholas, Liverpool's parish church. The base of its tower, begun in 1811 to the designs of the celebrated Chester architect Thomas Harrison, is on the right. The drinking fountain set into the church's boundary wall was erected in 1885 in memory of William Simpson, a philanthropist and advocate of temperance. Drinking fountains in the vicinity of the docks were provided as a wholesome alternative to the pub, and in Hardman's photograph this one is actually being used for its intended purpose.

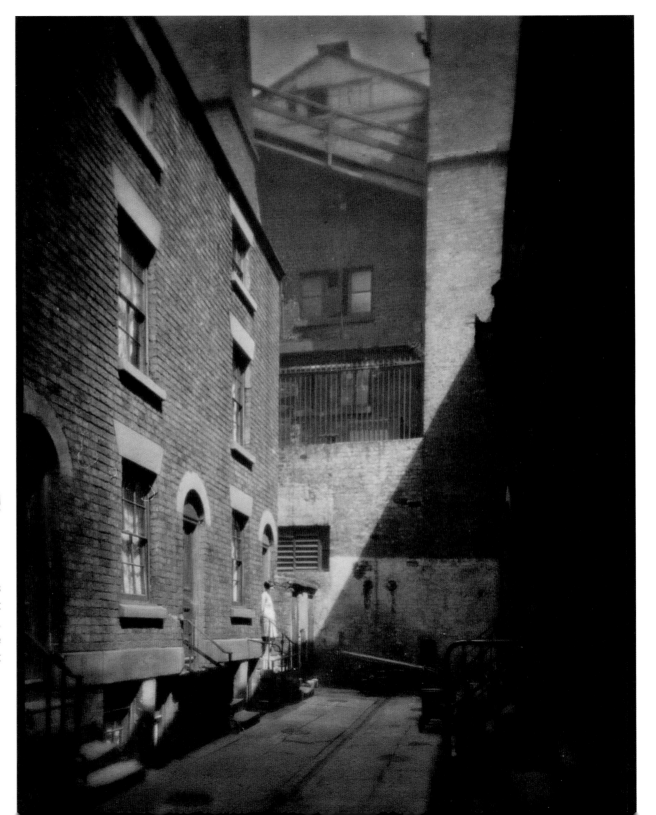

WOMAN ON DOORSTEP IN A LIVERPOOL COURT
1935

A classic example of a Liverpool court: two terraces of small houses face each other across a narrow space where fresh air and daylight cannot easily penetrate. Taller industrial buildings overlook one end, making the atmosphere even more oppressive. This court was in the vicinity of Wood Street, just a stone's throw from what were still at this date the luxurious shops of Bold Street.

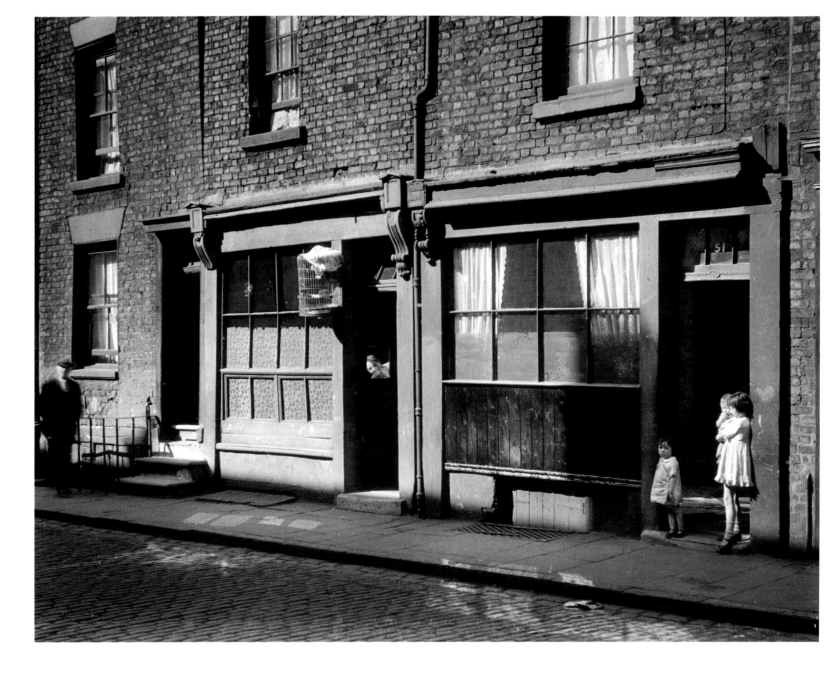

PITT STREET SCENE WITH BIRD CAGE
c. 1927

Pitt Street in the early 20th century was the heart of Liverpool's Chinatown. Charles Reilly described it in 1921 as 'a narrow, intimate thoroughfare of low Georgian houses and shops … In daytime it looks a little drab … but at night it improves. Through the deep, half-concealed entrances of the restaurants and clubs you see an occasional Chinese lantern or illuminated dragon.'

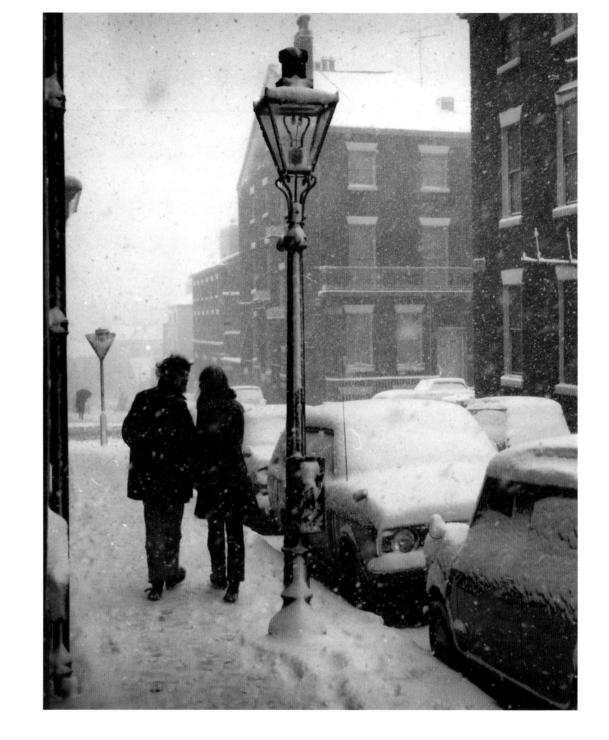

MOUNT STREET SNOW SCENE
c. 1965

This is only a few yards from the junction of Mount Street and Rodney Street – Hardman's studio is just round the corner to the left..

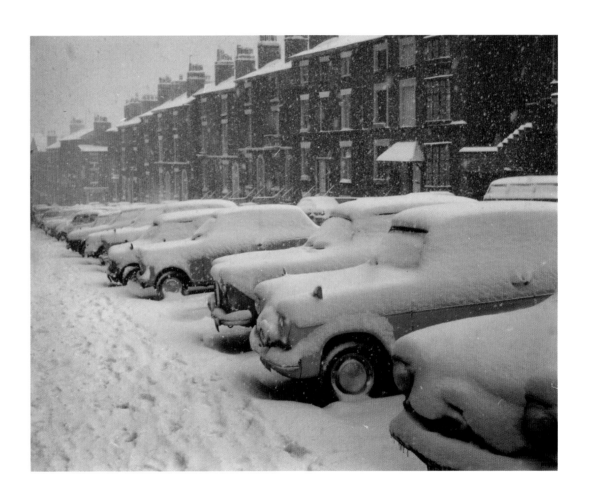

**SNOW-COVERED CARS,
MOUNT STREET
c. 1965**

Another snow scene just round the corner from Hardman's studio. The view is taken from almost the same position as the photograph on page 32.

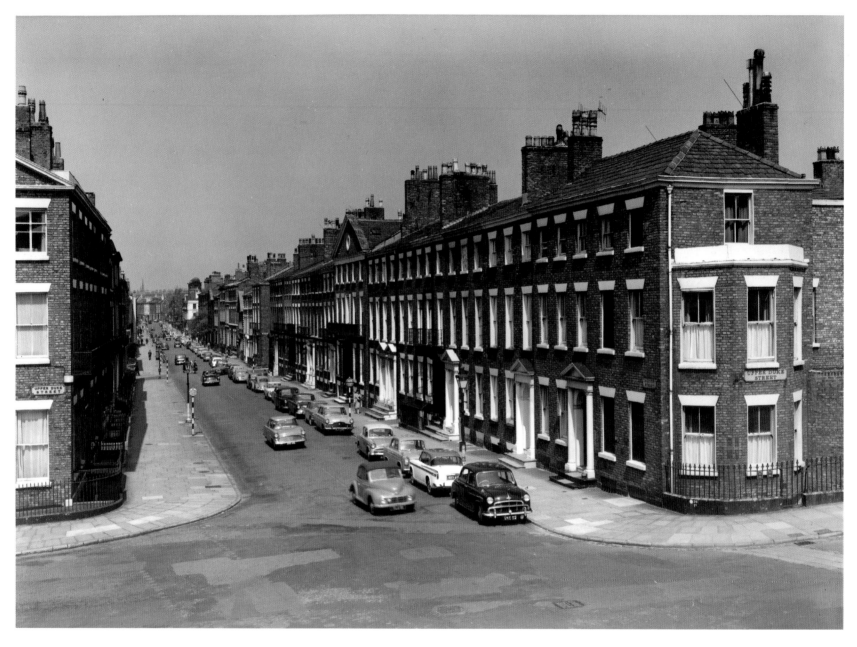

RODNEY STREET FROM UPPER DUKE STREET 1960s

Rodney Street was laid out in 1783–4. Broad and straight, and situated on high ground above the congestion of the old town centre, it was a very desirable address. It had parallel service streets which gave access to kitchens and stables at the rear of the houses, so that Rodney Street itself retained an air of quiet dignity. Many of the houses were built in pairs or short runs, but the long terrace comprising numbers 51A–75, on the right of Hardman's photograph, was designed as a unified composition with a central pediment. It was here, at number 59, that Hardman had his house and studio from 1949 to 1988.

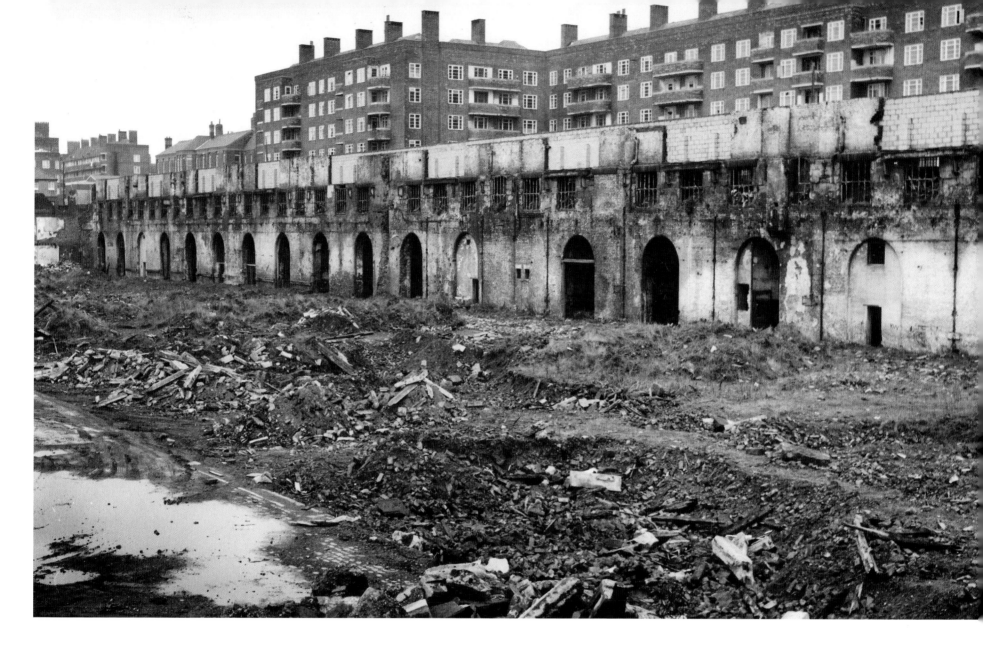

BRUNSWICK GARDENS

The rubble-strewn foreground is the site of the former Brunswick Goods Station. Overlooking this wasteland is Brunswick Gardens, one of many large blocks of tenement flats built by Liverpool Corporation between the two world wars. Designed under the Corporation's Director of Housing and City Architect, Lancelot Keay, these ambitious and impressive buildings were influenced by continental public housing schemes. Later they fell out of favour, and most were demolished in the 1980s and 90s to be replaced with informally grouped detached houses.

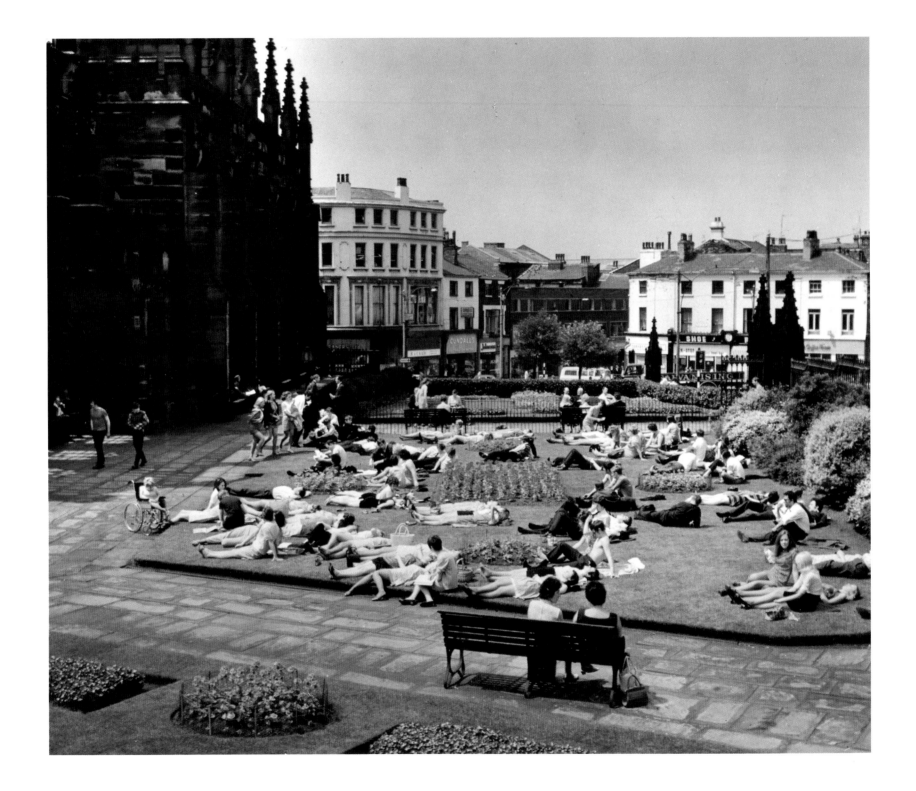

ST LUKE'S GARDEN
1960s–70s
(OPPOSITE)

BLUECOAT RAILINGS
1972
(ABOVE)

On the left is the shell of St Luke's church, still soot-blackened before its stonework was cleaned (see page 87). The large surrounding churchyard was never used for burials, and in 1885 it was laid out as a garden with lawns and flower beds. In a city with relatively few green open spaces in the centre, it remains a valuable asset. Hardman's photograph is not dated, but the fashions of the sunbathers suggest it was taken in the 1960s or early 1970s.

Bluecoat Chambers, in the background, was built as a charity school at the beginning of the 18th century, and is the oldest surviving building in the city centre. When the school moved to the suburbs in 1906 its former premises were occupied by the Liverpool School of Architecture for a time. It was also home to the Sandon Studios Society, a lively arts club where Hardman, in his own words, 'became intimately acquainted with a circle of practising architects, painters, sculptors and musicians'. Carefully restored after bomb damage in the Second World War, it became a popular centre for the visual and performing arts. Hardman had a one-man show here in 1968.

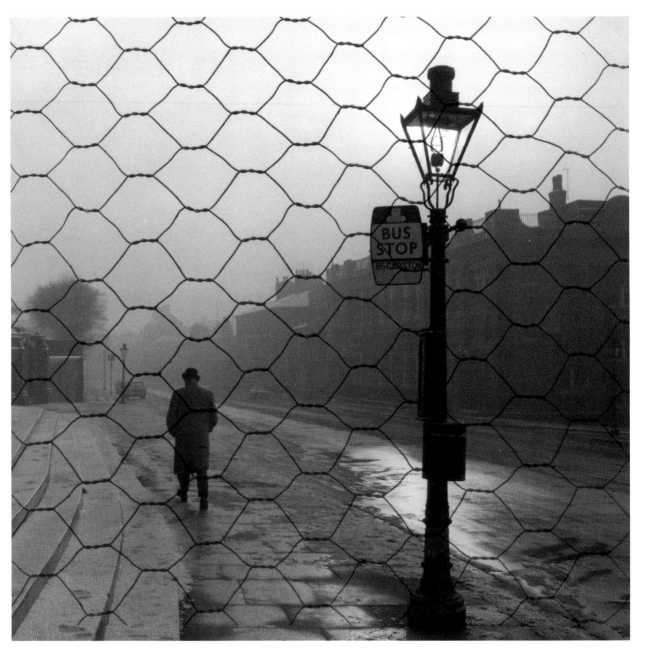

BUS STOP SIGN ON STREET LAMP 1960

A view of St James Road on the west side of the Anglican Cathedral. Following the redevelopment of the area round the cathedral in the 1980s, the road no longer exists in this form. It is a bleak enough scene – a street apparently leading nowhere, under an overcast sky – but Hardman chose to make it even grittier, superimposing a photograph of chicken wire over the original image, so that the viewer seems to be looking at this gloomy prospect through a makeshift fence.

GAMBIER TERRACE
1971

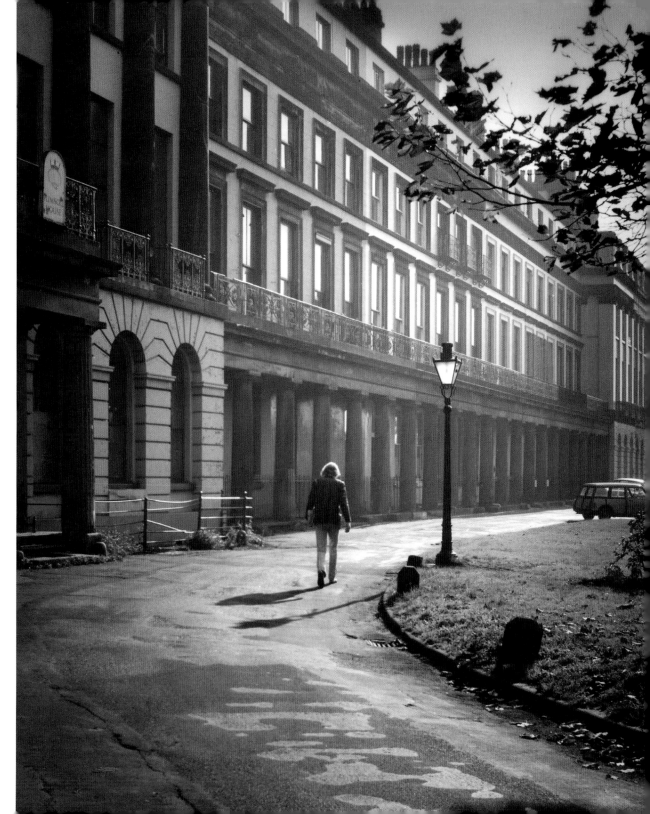

Begun in the early 1830s, Gambier Terrace was the grandest residential development of its date in Liverpool. The imposing Neoclassical houses were set behind a carriage drive and shrubbery, and from their elevated site they enjoyed views over the Mersey to the hills of north Wales. While the terrace was still only half built, however, suburban villas started to become more popular; the fashion for large houses near the town centre waned, and the original symmetrical design was never completed. In 1904 the gigantic Anglican Cathedral was begun on a site directly opposite, so that today the houses look out on a view of awe-inspiring splendour.

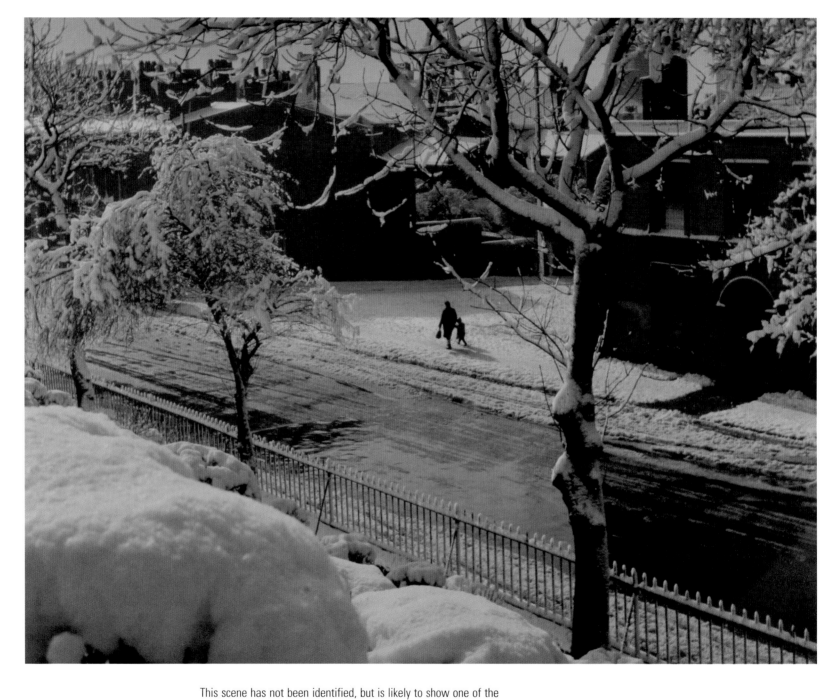

WINTER DAY, LIVERPOOL This scene has not been identified, but is likely to show one of the many late Georgian residential streets east of Rodney Street, possibly in the vicinity of Falkner Square.

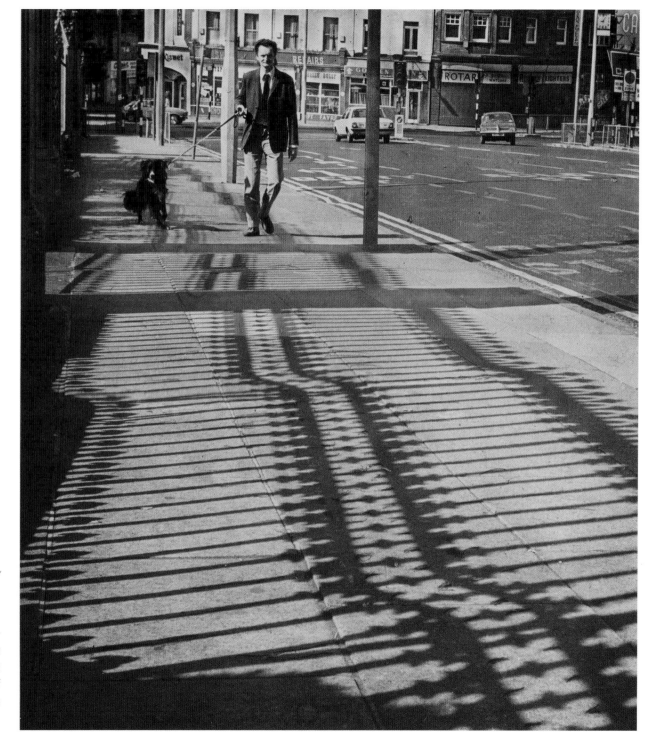

WAVY PAVY

The man and his dog are walking up Leece Street, past the bombed-out St Luke's church (see pages 22 and 87). The title refers to the undulating shadows thrown across the pavement by the cast-iron railings. These railings, made in about 1830 by the local foundry of Foster & Griffin, are of an unusually rich Gothic pattern that matches the architecture of the church.

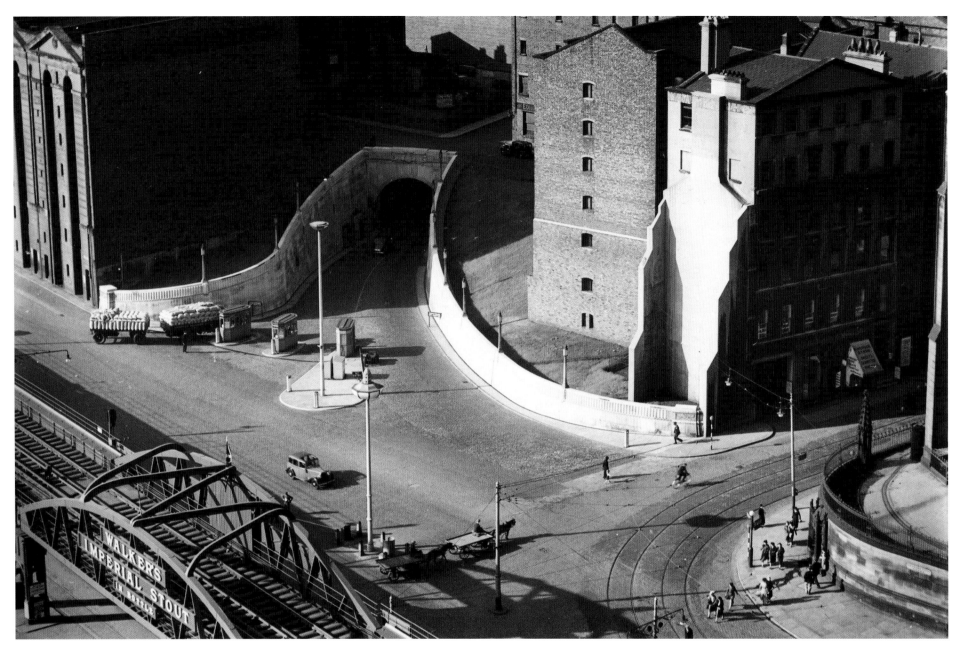

MERSEY TUNNEL, DOCK ROAD ENTRANCE

This must have been taken from high up in the Royal Liver Building. It shows the entrance to the branch of the first Mersey road tunnel that serves the docks, situated on New Quay near the corner of Chapel Street. Hardman shows how its sleek, white, curving walls have sliced through a dense mass of rugged, grimy, 19th-century warehouses: the tunnel is made a symbol of the contrast between the modern world and the old.

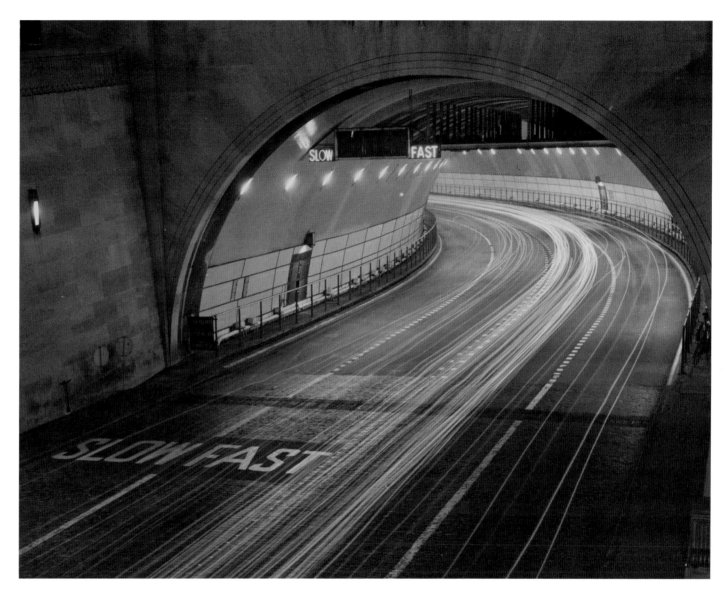

This is a night-time view of the Old Haymarket entrance to the first Mersey road tunnel, opened in 1934. The great semicircular portal, like all the architectural features of the tunnel, was designed by Herbert J. Rowse (see also pages 50–51 and 65). Inside, the lower part of the walls was originally clad in black glass framed in stainless steel, but this stylish feature had already been removed by the time this undated photograph was taken. The print was produced for an Army photographic class that Hardman ran in Chester.

MERSEY TUNNEL INTERIOR

GOREE PIAZZAS
1932

This photograph records one of Liverpool's most remarkable vanished sights. The Goree warehouses – named after the island off Senegal used as a transit point for the Atlantic slave trade – were two colossal six-storey buildings, dating originally from 1793, but reconstructed after a fire in 1802. They stood between the Strand and the Pier Head, until they were demolished following bomb damage in the Second World War. A traffic island in the dock road now occupies the site. At street level the warehouses had covered arcades, known as 'piazzas', which kept pedestrians safe from the dangers associated with goods being hoisted up and down outside.

CORNWALLIS STREET AND UPPER PITT STREET 1930s

Hardman took this photograph from the steeple of St Michael's church, a noble early-19th-century building modelled on St Martin-in-the-Fields in London. It stood at the heart of a grid of broad, regular streets that began to be developed with fashionable houses around 1800. Fashions change, however, and by the 1930s this was a poor and decaying district. In the May blitz of 1941 the church was bombed, and soon afterwards demolished. Today only the boundary wall of the churchyard is recognisable from Hardman's picture.

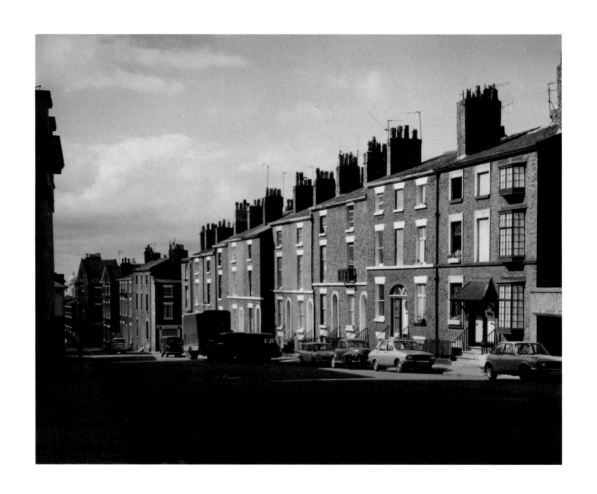

MOUNT STREET
1960s

Mount Street is just round the corner from Hardman's studio at 59 Rodney Street, and he photographed it several times (see pages 18 and 19). The small houses stepping down the hill were probably built around 1820. Just visible in shadow on the left is the portico of what in the 1960s was the Liverpool Institute boys' school. It has undergone a number of changes of use: built in the 1830s as the Mechanics' Institution, today it houses the Liverpool Institute of Performing Arts.

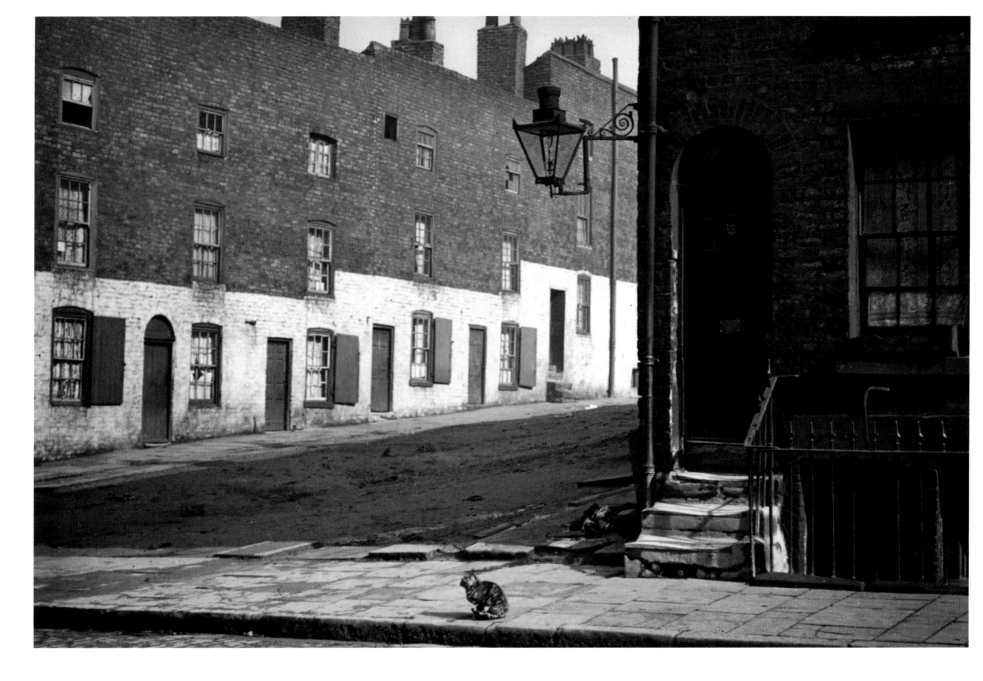

UNIDENTIFIED STREET SCENE WITH CAT

Liverpool's rapid expansion in the early 19th century saw the construction of numerous streets of late-Georgian terraced houses, climbing uphill from the old town centre. The houses in this unidentified example are of the smallest kind – each just one bay wide – and the windows are unusually small.

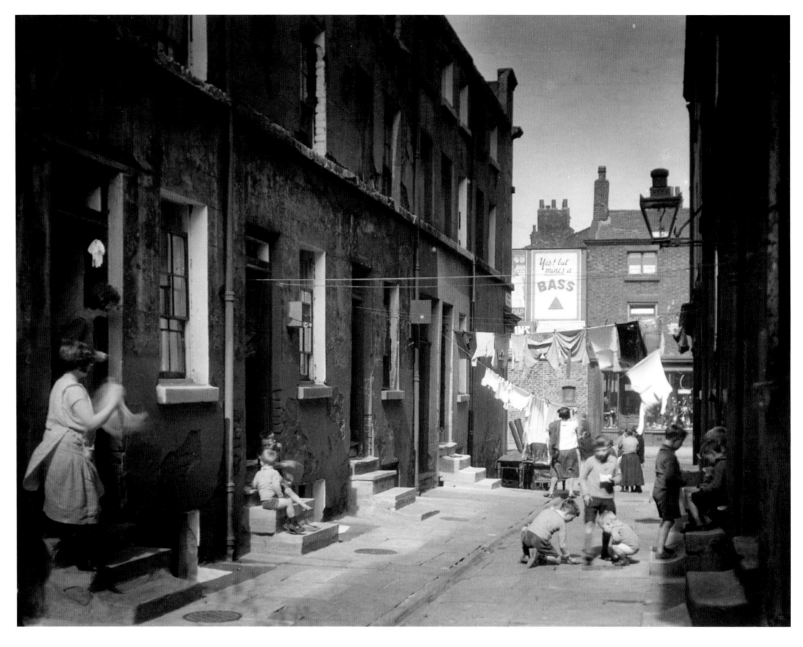

BEAU COURT WITH BASS SIGN
c. 1927

Liverpool's 19th-century courts – narrow cul-de-sacs of poor quality housing – were notorious for dirt, poverty and overcrowding. In Hardman's photograph, however, this example seems quite clean and bright. He wrote of Beau Court: 'It looks rather a slum but the people who lived there were kind and helpful to each other and there was no wall scribbling or vandalism'. Beau Court stood in an area that was completely transformed in the 1960s to make way for the approaches to the second Mersey road tunnel, Kingsway.

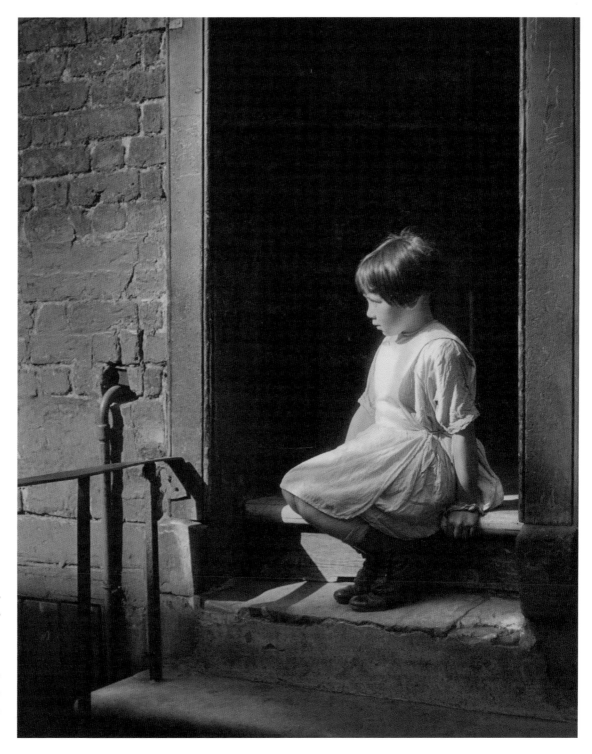

LITTLE INHABITANT
OF PITT STREET

A portrait of Elsie Kooloi seated on her doorstep in Pitt Street, in the heart of Liverpool's China Town (see also page 17). Hardman wrote that this was the first of a series of photographs intended to illustrate the rich ethnic mix of the Pitt Street neighbourhood.

INDIA BUILDINGS, DOORWAY WITH FIGURE

This is the Brunswick Street entrance to the shopping arcade that runs through the middle of India Buildings. The figure is probably Hardman's wife Margaret, included both to animate the scene and to give an idea of the scale of the enormous archway. The giant bronze lamps flanking it were made by the Bromsgrove Guild and are modelled on those of the Strozzi Palace in Florence. Just inside the entrance is an advertisement for the Mecca Café, which had a branch in the basement.

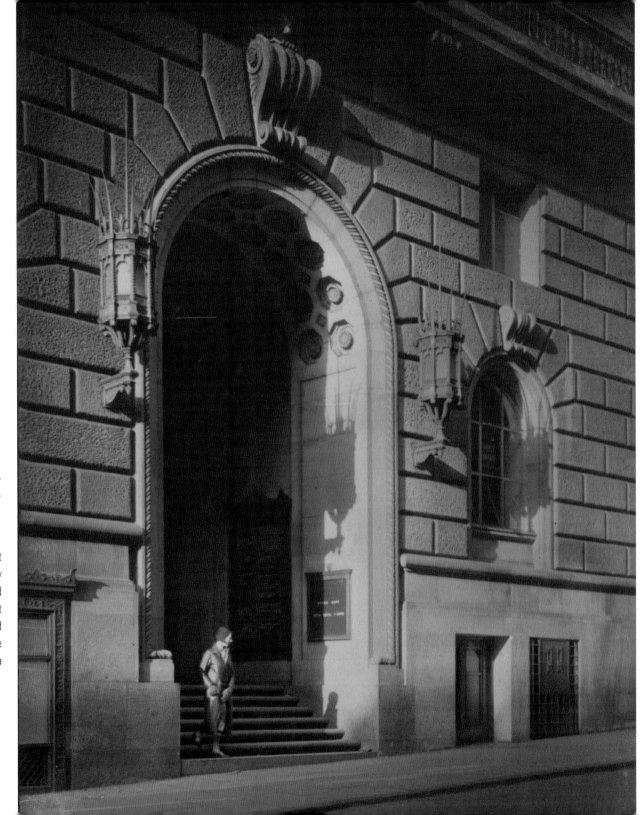

FIGURES IN A DOORWAY, VERNON STREET
c. 1930

These houses have been demolished, and very little now remains of Vernon Street's late Georgian architecture. Single, broad arches enclosing the twin doors of adjoining houses can be seen elsewhere in Liverpool, for example in Mount Street (see page 32), but the deep recess in front of this Vernon Street pair is unusual. The intention may have been to keep the pavement free from obstruction by setting the front steps back behind the building line.

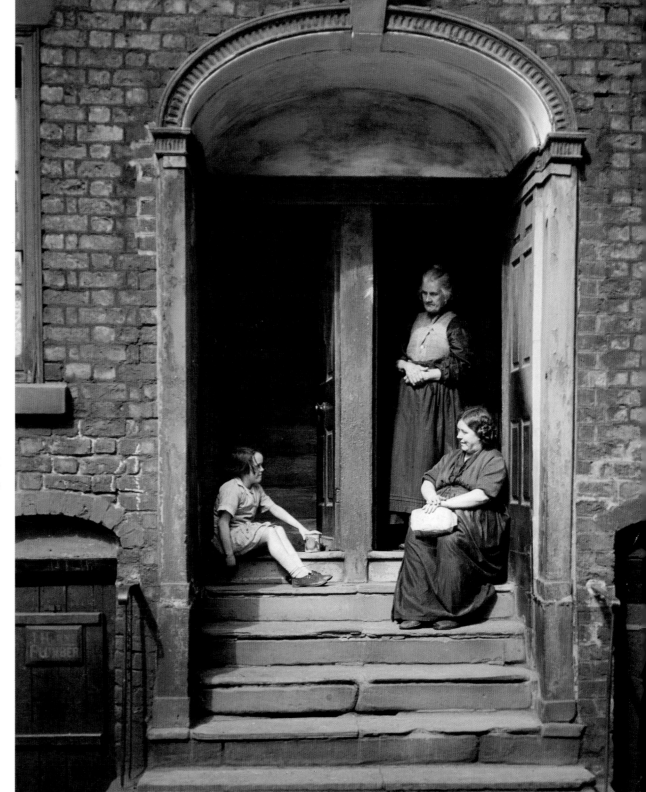

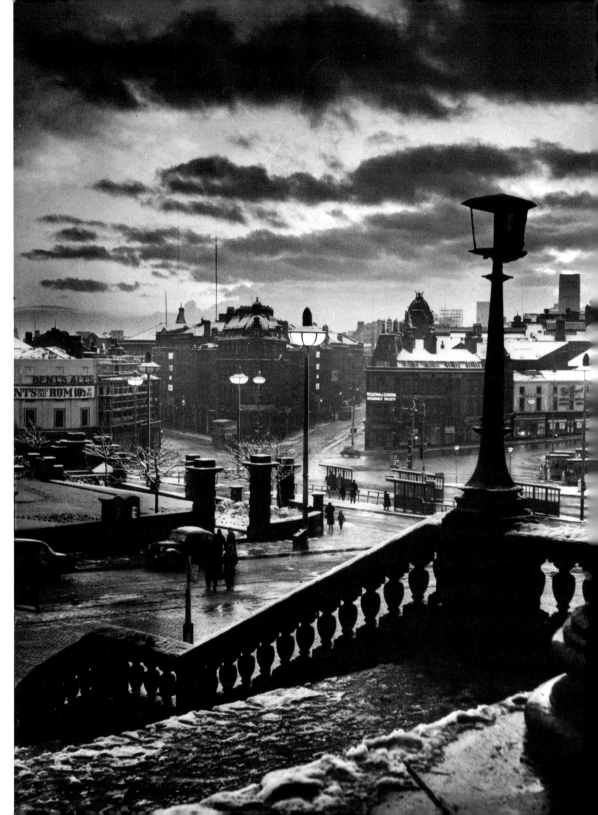

MUSEUM STEPS
1946

The flight of steps in front of the Liverpool Museum (now known as World Museum Liverpool) commands a panorama over the city centre. Despite some demolitions, it is a view that has not changed greatly since this photograph was taken shortly after the Second World War. Hardman was more interested in effects of light and atmosphere than in individual buildings. The picture captures the early dusk of a winter's afternoon, with the street lamps just starting to emerge from the deepening gloom. Hardman enhanced the wintry feel of the image by toning the print with gold chloride to give it a blue cast.

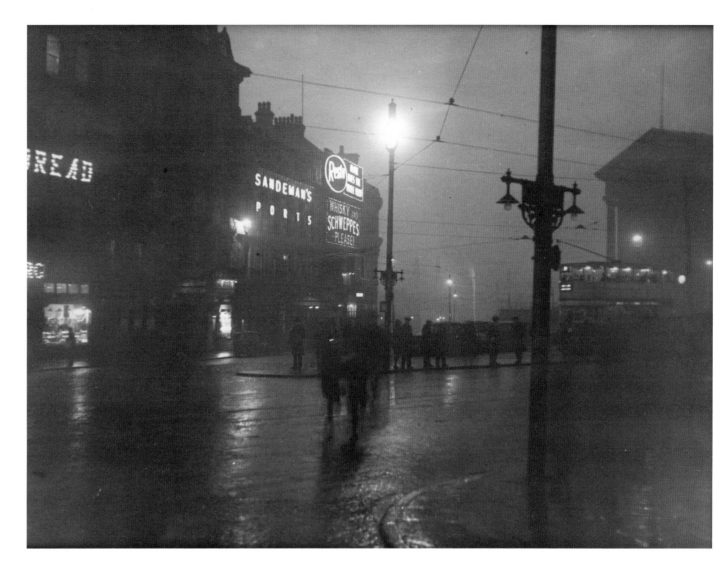

LIME STREET AT NIGHT
1950s

Hardman's camera is looking north-west along Lime Street towards St John's Lane. On the right, the south portico of St George's Hall looms in silhouette above a brightly lit tram. The illuminated advertisements are a reminder that Lime Street was for a long time associated with nightlife and entertainment, though less evidence of this can be seen today. The buildings on the left were demolished in the 1960s to make way for the St John's Precinct shopping centre.

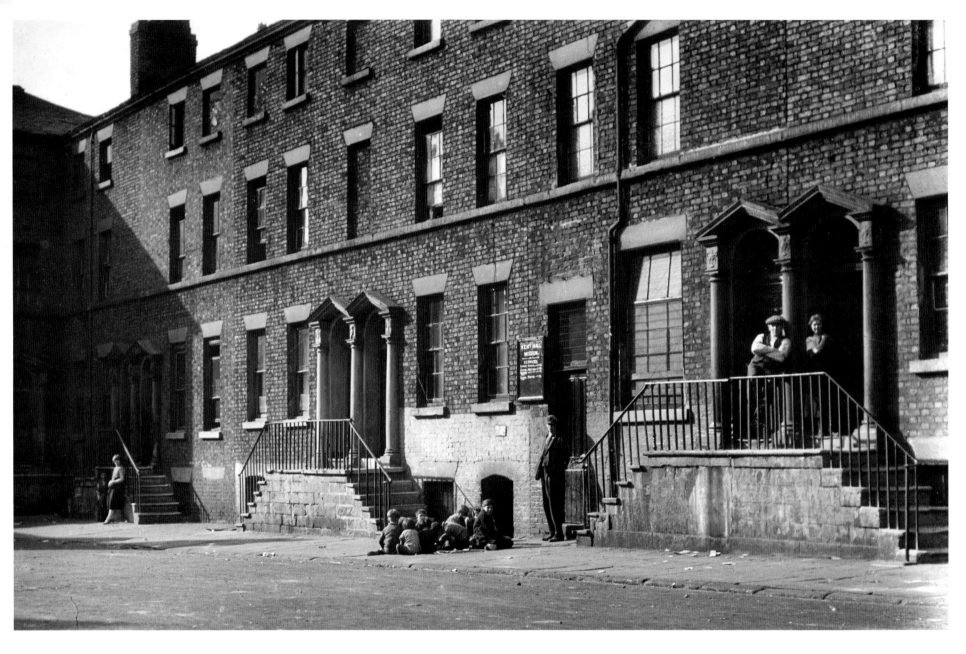

KENT SQUARE
1925

'That jewel in an ancient setting' is how Charles Reilly, Professor of Architecture at the University of Liverpool, described Kent Square in 1921. 'It is like a Cambridge court rather than a square, only it is Georgian, with all the elegance that implies. The houses are small and refined … each doorway is pedimented, and … many of the doors – neat six-panel doors with raised panels – have their Georgian knockers left. It is altogether charming.' Despite Reilly's rhapsody, however, Kent Square had by this date sunk into poverty, as Hardman's photograph shows.

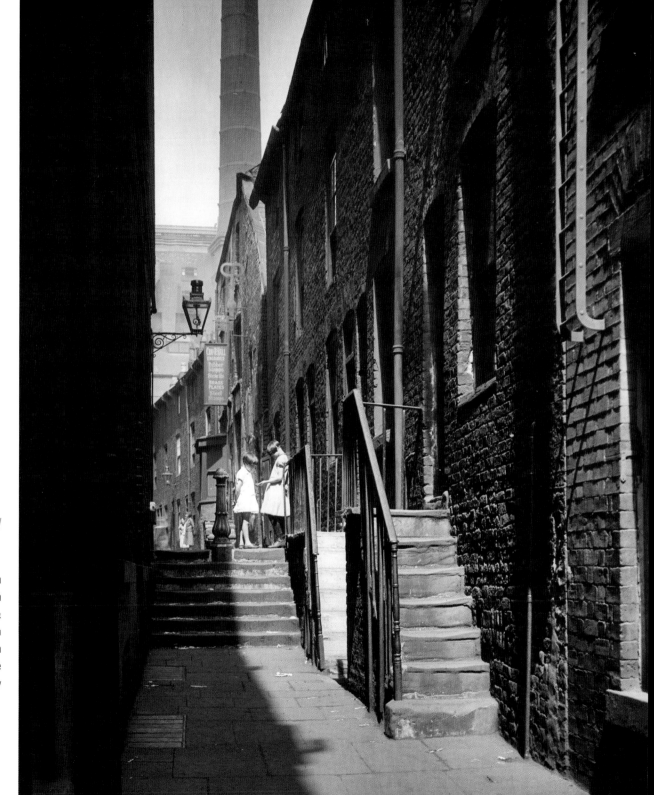

GIRLS BY ENGRAVER'S SIGN

This appears to show a scene in Hale Street (little more than an alley, in fact) running north from Dale Street, parallel with Vernon Street. In the background rises the very tall chimney of Macfie & Co.'s sugar refinery. All these buildings have since been demolished, and Hale Street itself no longer exists in the form shown here. Hardman would have had to wait patiently and seize his chance to take this picture: sunlight would penetrate this narrow passage only briefly in the middle of the day.

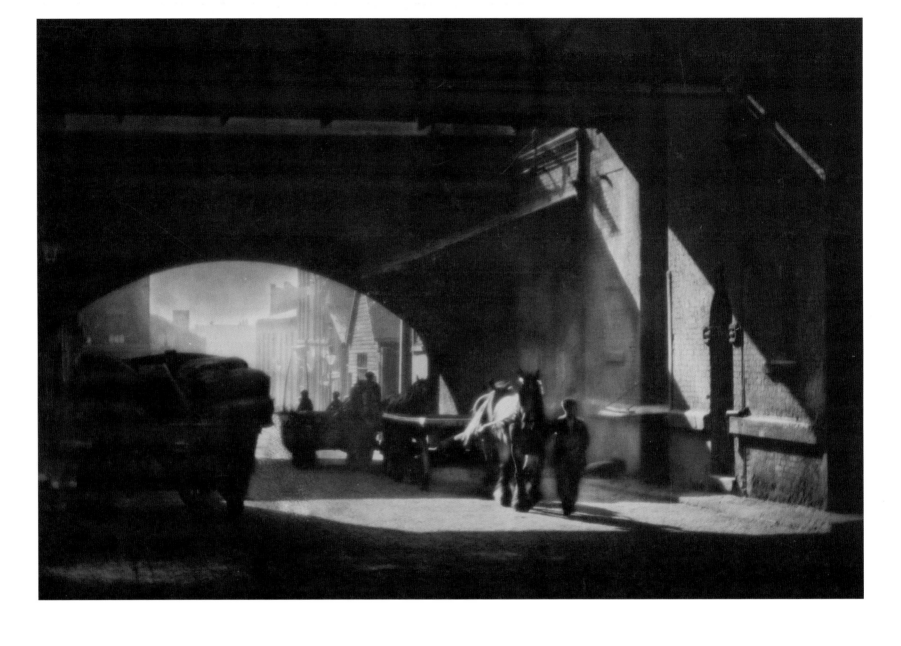

**LITTLE HOWARD STREET
1928**

One of many narrow streets leading down to the docks, just north of the office district. This area was once dominated by lofty warehouses and slow-moving carts with heavy loads. The street runs under two parallel railway viaducts, one dating from 1846–8, the other from the 1880s. Originally they carried commuter trains from Southport into Exchange Station, but today they are linked with Liverpool's underground railway system. Sensitive to the peculiar beauty of this industrial landscape, Hardman wrote of the picture: 'A soft focus technique has been used here to emphasize the luminosity of the dusty atmosphere seen against the light'.

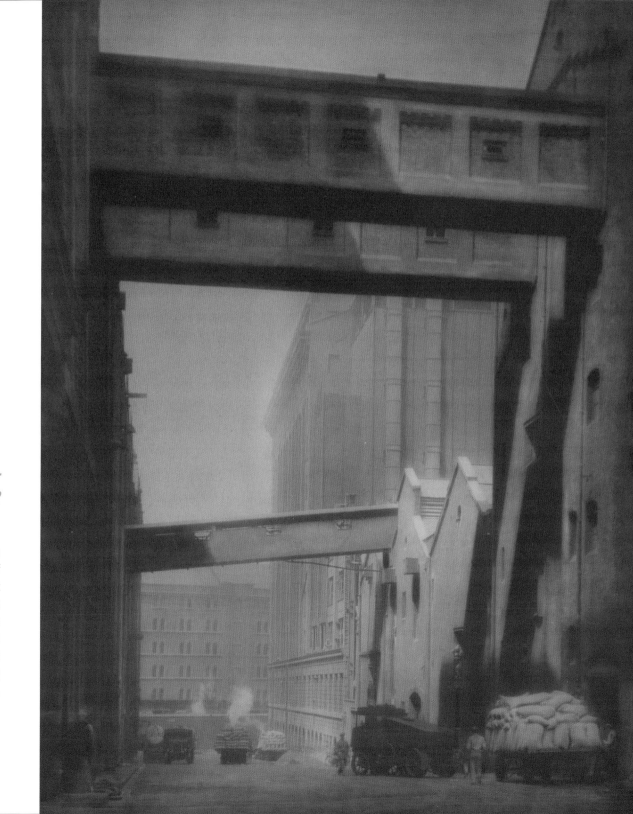

NEPTUNE STREET
1932

Closing the view down this canyon-like street is the massive 1860s grain warehouse at East Waterloo Dock, recognisable by its rows of arched windows in pairs.This mighty building still survives, but Neptune Street is no more. Here and in neighbouring streets in the late 19th and early 20th centuries arose a group of huge buildings that housed the animal feed manufacturing business of J. Bibby & Sons. Proximity to the supply of grain from the docks was important to its success. Hardman's photograph shows how the sprawling complex of mills and warehouses was linked by high-level bridges.

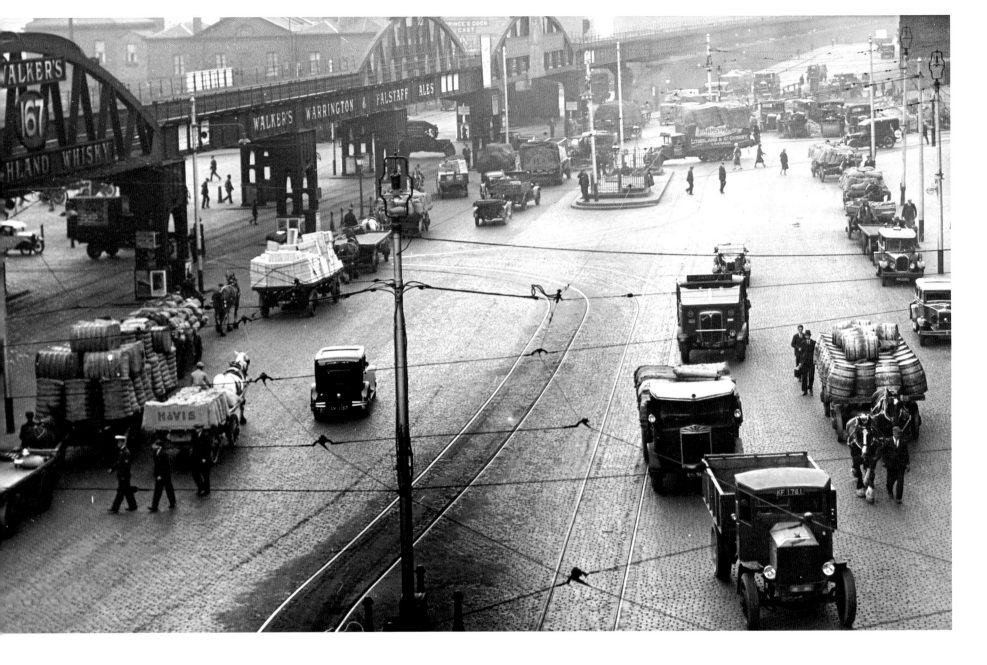

OVERHEAD RAILWAY
AND DOCK ROAD
1922

The busy dock road, which used to mark the boundary between the city's central business district and the dock estate, is shown characteristically thronged with vehicles – in fact, this picture was commissioned by the BBC precisely to show the variety of traffic.

The Overhead Railway ran above the road on an iron and steel viaduct, in order not to impede access to the waterfront. Opened in 1893 and demolished in the 1950s, it was the first elevated electric railway in the world.

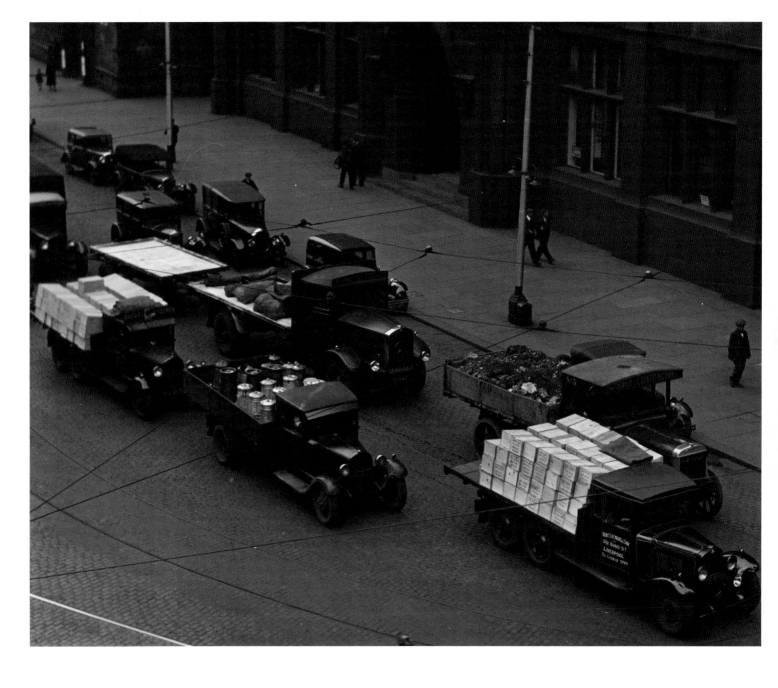

**DOCK ROAD TRAFFIC
1940s**

These lorries are travelling south along the stretch of the dock road known as George's Dock Gates. In the background is Tower Buildings, an office block at the corner of Water Street (see also page 83). Hardman probably looked down on this busy scene from the neighbouring Cunard Building.

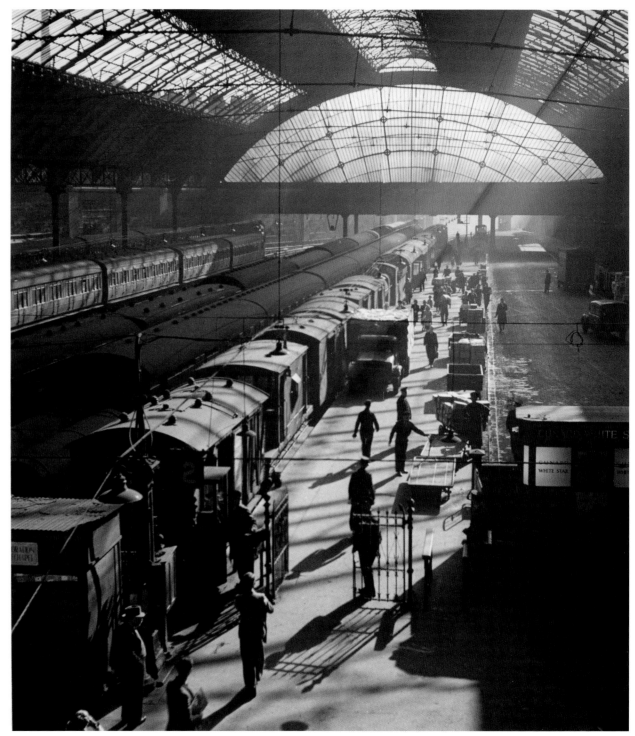

CENTRAL STATION IN THE 1960s

At this date Central Station in Ranelagh Street had two distinct parts. There were low level underground platforms serving the Wirral, and high level surface platforms for trains to the southern suburbs and beyond. Hardman's photograph shows the high level platforms under their splendid glass and iron roof of 1874.

CENTRAL STATION DEMOLITION
1973

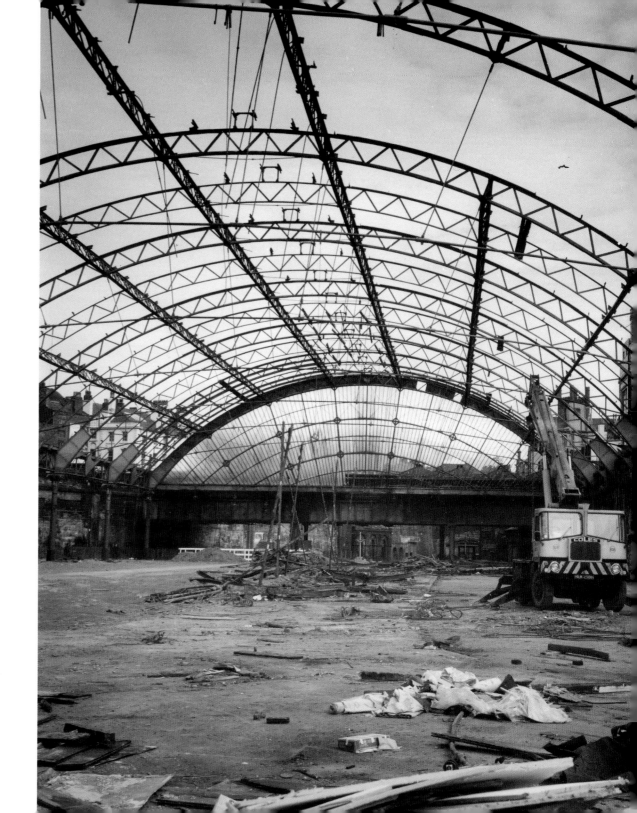

In 1972 the last remaining train services from Central Station's high level platforms were diverted to Lime Street, and the following year the station roof was demolished. Hardman's photograph records the melancholy process of destruction, with the tower of St Luke's church just visible on the right through the skeletal trusses.

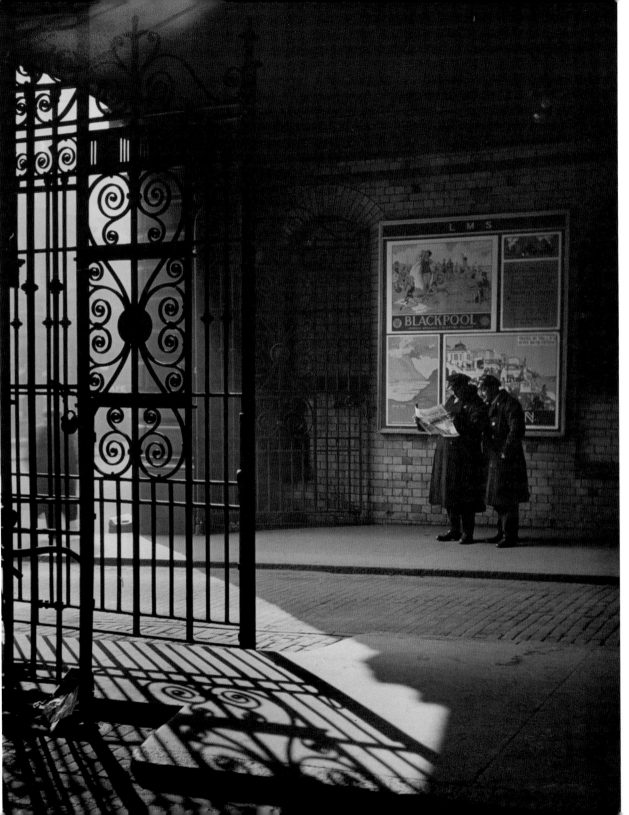

GATES TO EXCHANGE STATION
1930s

Exchange Station in Tithebarn Street was the Liverpool terminus of the Lancashire & Yorkshire Railway. By the time this photograph was taken, the company had been absorbed into the London Midland and Scottish Railway, so it is the LMS's initials that appear on the notice board in the background. The station took its name from the nearby Liverpool Exchange (see opposite) – the heart of the office district – and was used by business commuters from affluent suburbs along the coast towards Southport. It closed in 1977, replaced by the new Moorfields underground station nearby. Its imposing façade survives, however, including this arched gateway. It now fronts a modern office block called Mercury Court.

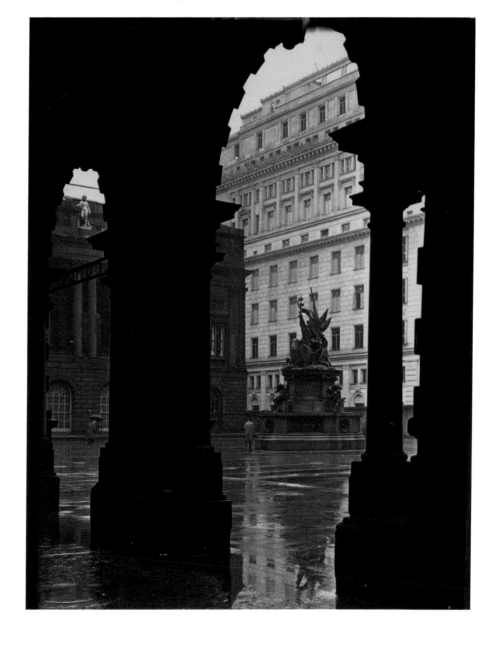

EXCHANGE FLAGS
1935

Exchange Flags is the name of the square (originally paved with flagstones) just behind the Town Hall, surrounded on its other three sides by the Exchange Buildings. Created in 1803–8, it was the outdoor meeting place of Liverpool merchants for more than a century, and the busy hub of the city's commercial life. The Exchange Buildings were demolished and rebuilt in the 1860s, and again in the 1930–50s. Hardman's view is taken from within the ground-floor arcade of the 1860s buildings. In the background is the towering flank of the newly completed Martins Bank (see page 82). In the centre of the Flags stands the Nelson Monument, unveiled in 1813.

MERSEY TUNNEL VENTILATION TOWER
1934

There are three ventilation towers at the Liverpool end of the tunnel, all designed by Herbert J. Rowse (see also opposite and page 65). This one is in North John Street, and was photographed by Hardman in 1934 as construction neared completion. Situated in the heart of the business district, it was faced with Portland stone to suit its dignified setting. Even so, its enormous height and windowless, cliff-like walls make a striking contrast with the surrounding Victorian office buildings, such as Rigby's Buildings in Dale Street, visible in the distance.

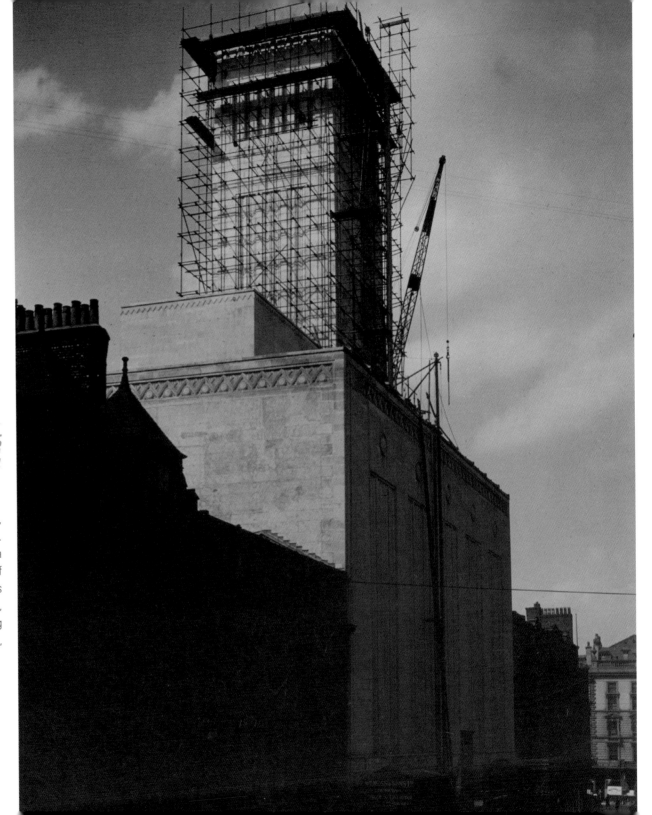

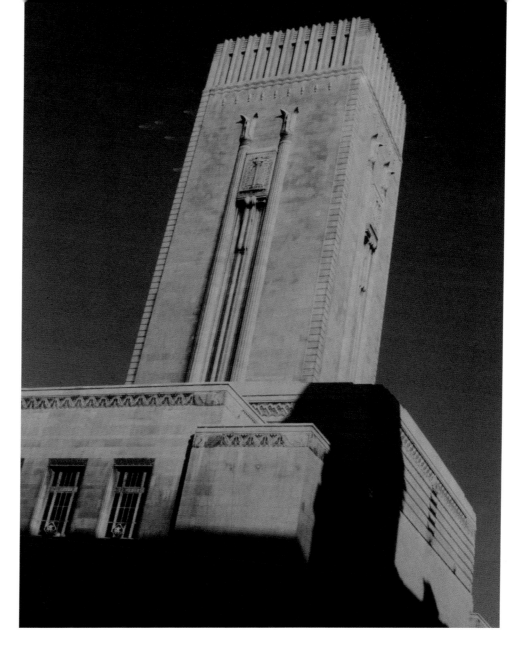

GEORGE'S DOCK VENTILATION AND CONTROL STATION

Situated between the Pier Head and the dock road, this is the principal building associated with the first Mersey road tunnel. It houses administrative offices as well as giant fans that suck dirty air out of the tunnel and blow clean air in. Damaged by bombing in the Second World War, it was largely rebuilt in the early 1950s under the supervision of the original architect, Herbert J. Rowse. Hardman's photograph highlights the Art Deco carved decoration by Edmund C. Thompson and George T. Capstick, which has a distinctly Egyptian character.

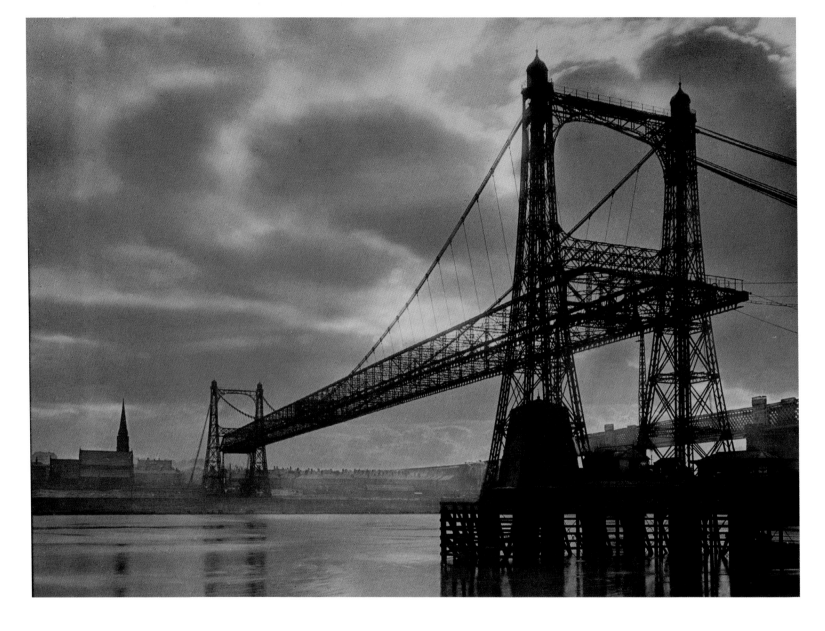

LINK WITH CHESHIRE: THE TRANSPORTER BRIDGE, RUNCORN c. 1939

The broad river Mersey is a major barrier to travel between Liverpool and the South. The narrowest point upstream from the city is the Runcorn Gap, where in 1864–68 the Britannia Bridge was constructed to carry the main railway line from London to Liverpool. It was followed in 1901–05 by this transporter bridge for road traffic. Vehicles and pedestrians were conveyed over the river (and the parallel Manchester Ship Canal) by a cable-hauled 'car', suspended from the latticework bridge. By the 1950s the volume of motor traffic had increased so much that a proper road bridge was needed (see opposite), and when it opened in 1961 the transporter bridge became redundant.

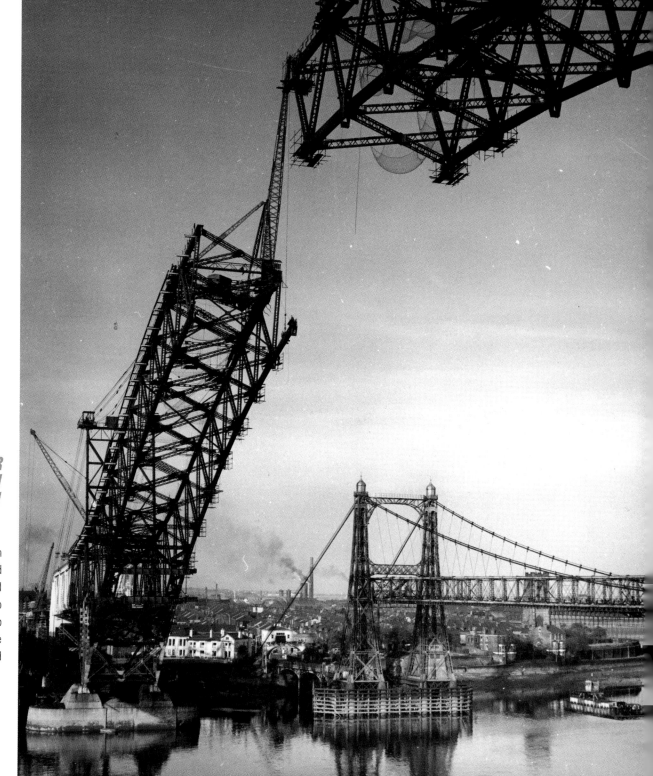

RUNCORN BRIDGE UNDER CONSTRUCTION 1960–61

This shows work in progress on the road bridge between Widnes and Runcorn, a major work of engineering which opened in 1961. With a span of 330 metres, it was the largest steel arch in Europe. It was designed by Mott, Hay & Anderson to carry traffic over the River Mersey and the Manchester Ship Canal, replacing a transporter bridge of 1905 (visible in the background) which was demolished when the new bridge opened (see opposite).

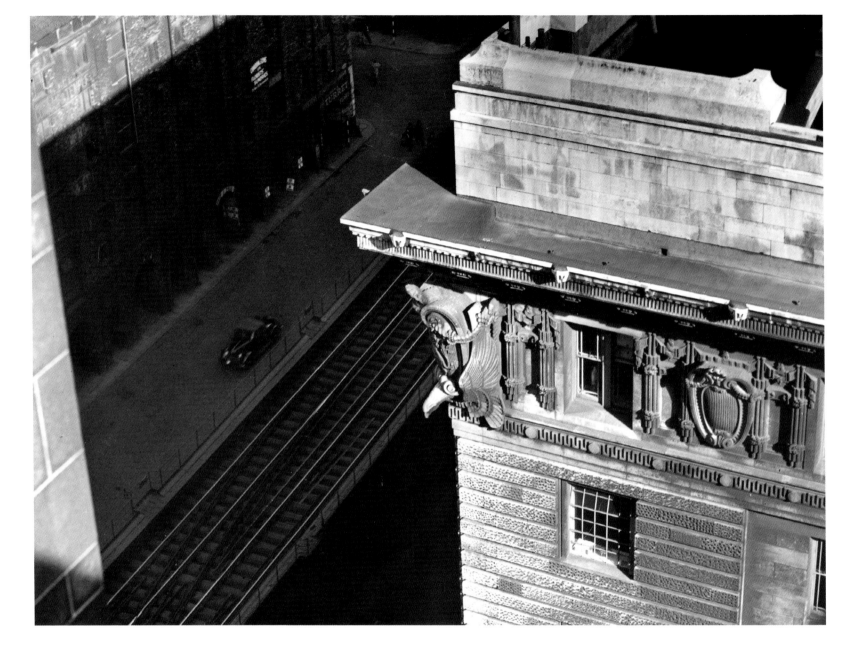

CUNARD BUILDING PARAPET
1937

Hardman's high vantage point on the neighbouring Royal Liver Building allowed him to show part of the frieze of the Cunard Building in close-up. The frieze was carved by the sculptor E.O. Griffiths, but for the corner eagles Griffiths worked from models supplied by Charles John Allen, Vice-Principal of the City School of Art in Mount Street. Far below in deep shadow are the parallel tracks of the Overhead Railway, and the Goree Warehouses with their ground-floor arcade (see pages 30 and 44).

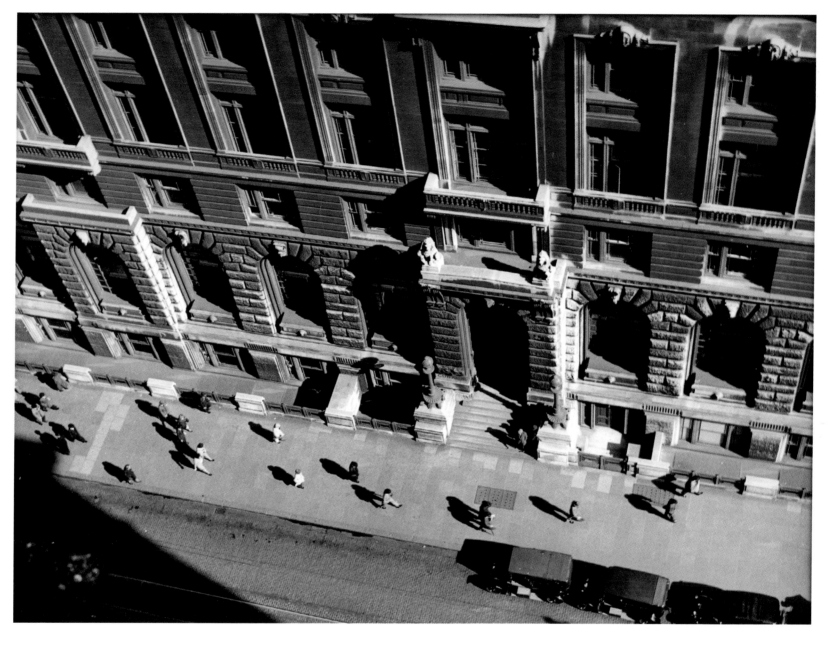

CUNARD BUILDING, BIRD'S EYE VIEW 1936

This is a view down onto the mighty Cunard Building from its even bigger neighbour, the Royal Liver Building. The dramatically foreshortened figures in Water Street cast long shadows in the afternoon sun. The Cunard Building was designed by Arthur J. Davis – one of the architects of London's Ritz Hotel – in conjunction with the local practice Willink & Thicknesse. It was the headquarters of the famous transatlantic steamship company whose name it bears, and also served as its passenger terminus, containing booking hall, waiting rooms and baggage storage.

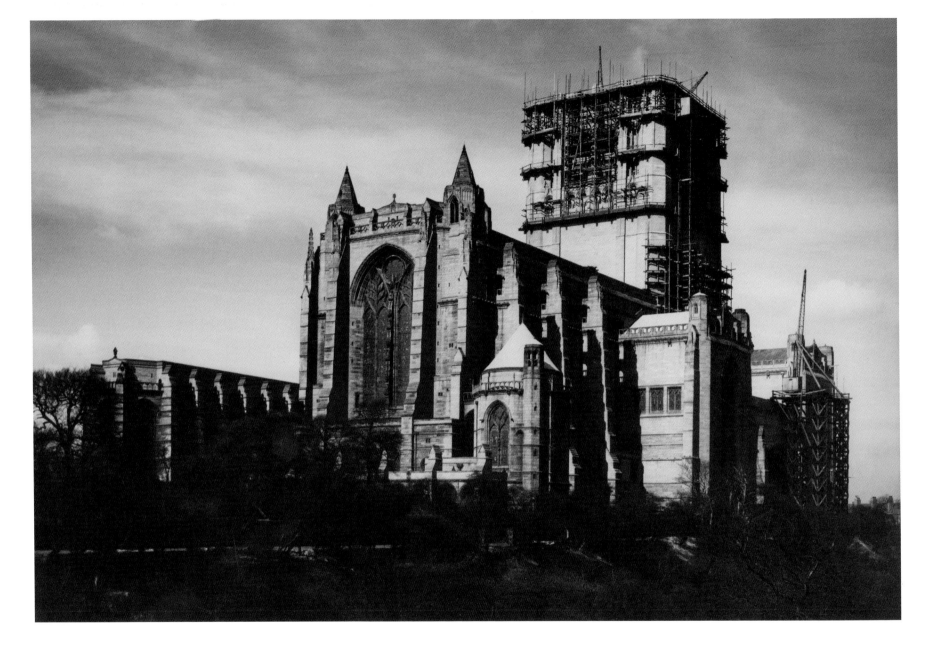

ANGLICAN CATHEDRAL TOWER UNDER CONSTRUCTION. 1935–36

The foundation stone of Liverpool Cathedral was laid by King Edward VII in 1904. Work progressed steadily for three quarters of a century until the finished building was dedicated in the presence of Queen Elizabeth II in 1978. It was paid for with funds raised locally, particularly from the city's wealthy merchant class. The great central tower, 101 metres high, was the gift of the Vestey family of meat importers, whose business originated in Liverpool. Its construction continued while bombs fell around the cathedral during the Second World War, until its final pinnacle was set in place in 1942 (see also opposite).

SEARCHLIGHT ON THE ANGLICAN CATHEDRAL 1951

This striking photograph was taken during Liverpool's celebrations for the 1951 Festival of Britain. The searchlight is positioned in front of the Liverpool Art School at the south end of Hope Street. In the area of shadow below the beam of light the unfinished nave of the cathedral can be made out. The cathedral can no longer be seen from this point, the view being blocked by a large extension to the Art School opened in 1961.

ATHENAEUM INTERIOR
c. 1928

The Athenaeum was established in 1797 as a combination of private library, newsroom and gentlemen's club. Its original premises were in Church Street, but when these were acquired by the Corporation for street widening, a large new building in Church Alley was erected in 1926–28. Designed by Harold Dod in a refined, French-influenced classical style, it overlooks the 18th-century former Blue Coat School. Hardman's photograph was evidently taken when it was only just complete, and before it had been furnished.

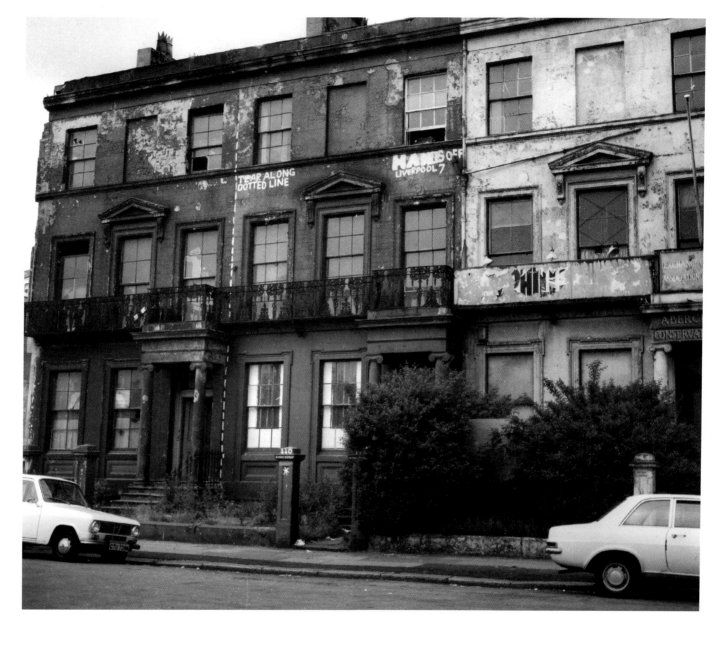

'HANDS OFF LIVERPOOL 7'
c. 1972

At the time Hardman took this photograph, large areas of Liverpool's once dignified Georgian housing had sunk into squalor or been lost to redevelopment. Demolition by the Corporation or the expanding University threatened what remained. The graffiti on this house refers to the approaching bulldozers, which have already devoured one end of the terrace. Its location is not recorded, but it may have been in Bedford Street South, where two houses of identical design still stand today. Happily, official attitudes changed in the 1980s, and much has since been done to preserve the surviving architecture of this remarkable area.

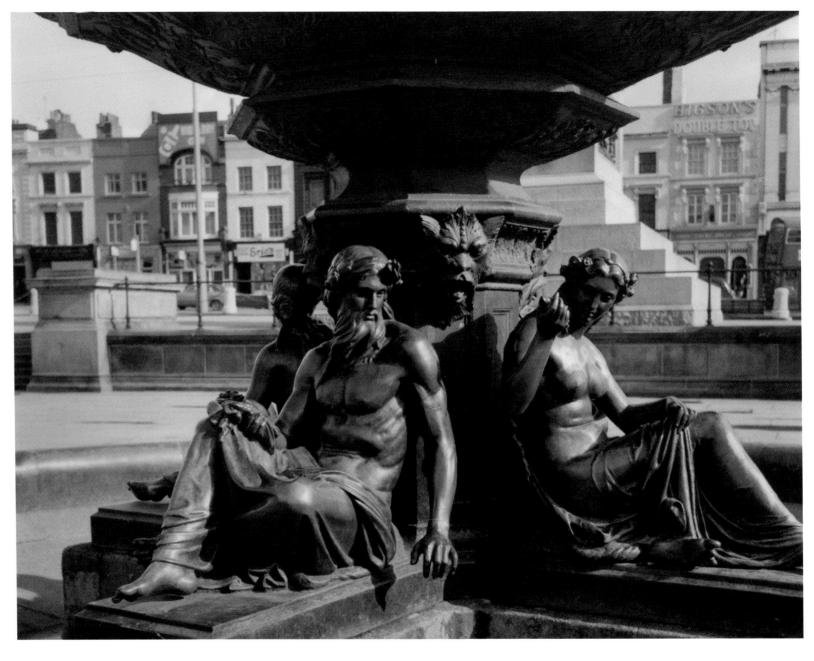

BASE OF STEBLE FOUNTAIN
1960s–70s

The cast-iron Steble Fountain – waterless in this photograph – stands at the top of William Brown Street, between the Walker Art Gallery and St George's Hall. It was the gift of Lieutenant Colonel R.F. Steble, and was unveiled in 1879. The figures round the base represent the marine deities Neptune, Amphitrite, Acis and Galatea. Other versions of what was evidently a popular design are in Boston, Launceston and Geneva. The sculptor was Paul Liénard.

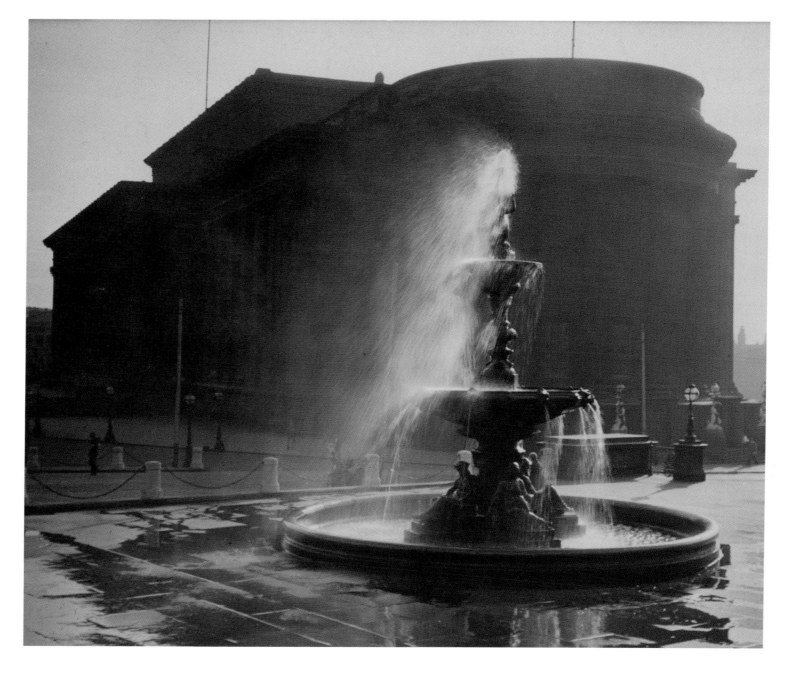

STEBLE FOUNTAIN AND ST GEORGE'S HALL

As soon as the Steble Fountain was inaugurated it was clear that its windy setting would cause problems: if enough pressure was used to produce a good jet of water, passers-by were likely to get a soaking. Hardman's photograph illustrates this, but also captures the exhilarating effect of sunlit spray against the dark, brooding bulk of St George's Hall.

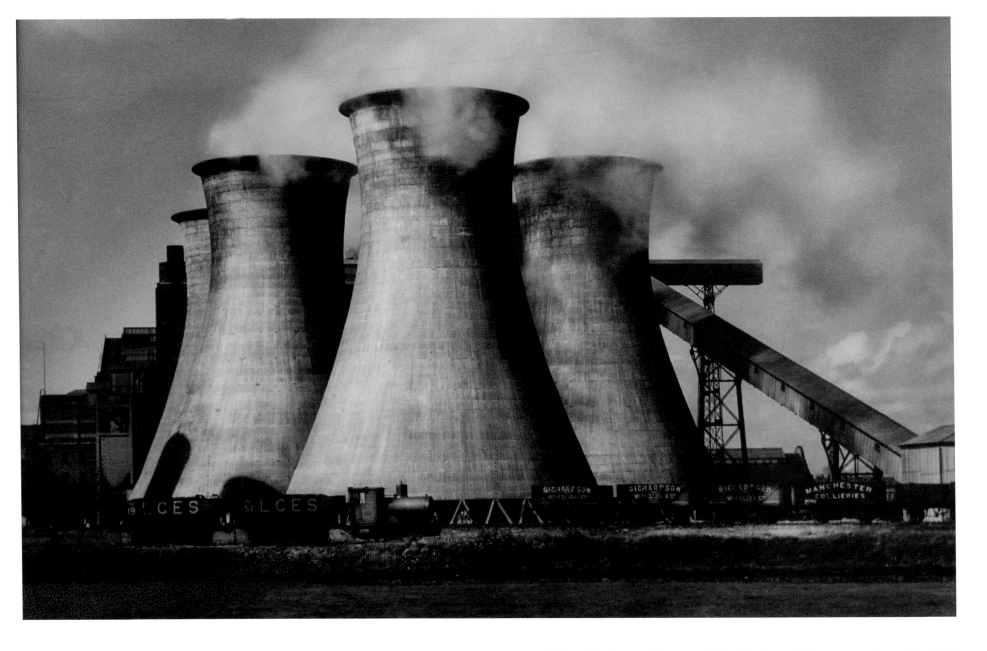

LISTER DRIVE POWER STATION
1929

In 1900 Liverpool Corporation began building the Lister Drive Power Station to generate electricity for lighting and for the city's tramways. These reinforced concrete cooling towers belong to a major extension opened in 1926. They were of a type developed in Holland, and Hardman believed they were the first such to be built in Britain. They were designed by the specialist concrete engineers Mouchel & Partners, who fifteen years earlier had designed the frame of the Royal Liver Building. Coal was delivered to the station by rail, using rolling stock owned by the Corporation's Electric Supply Department.

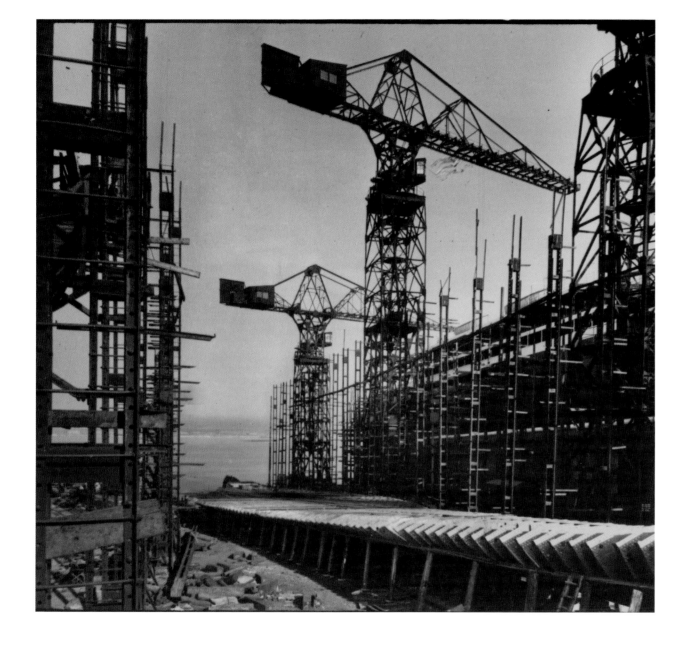

CONSTRUCTION, CAMMELL LAIRD
1931

William Laird was the founder of modern Birkenhead, establishing a boiler-making business there in the 1820s that quickly grew into a major shipyard. In 1903 the firm amalgamated with the Sheffield steel manufacturer Charles Cammell & Co. Ltd to become Cammell Laird. Hardman's photograph shows the colossal scale of shipbuilding operations at the yard by the early 20th century. The outline of the vessel under construction can be made out through the dense scaffolding.

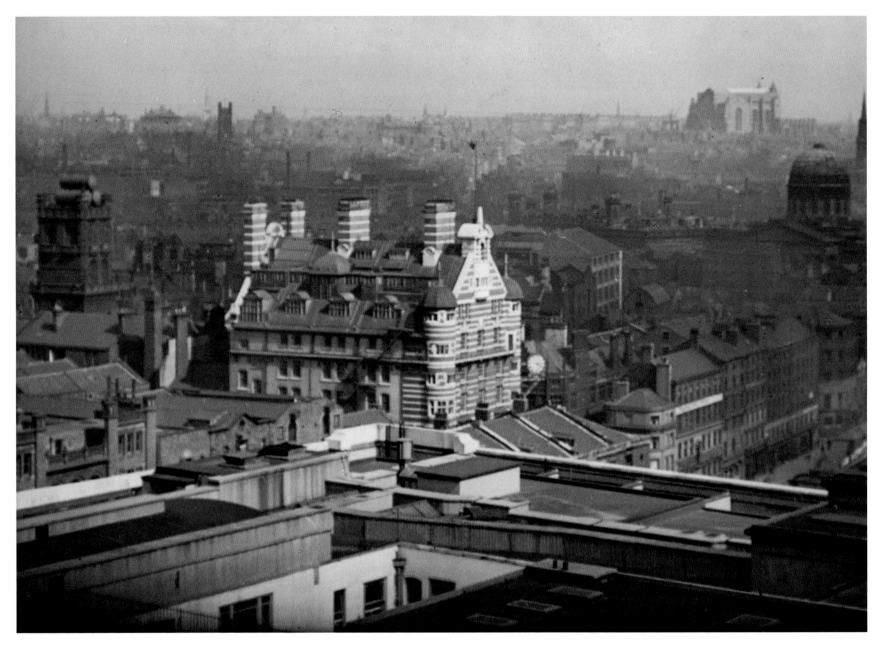

THE WHITE STAR LINE BUILDING FROM THE ROOF OF THE CUNARD BUILDING

Dominating the picture is the distinctive headquarters of the White Star Line, striped with alternate bands of brick and stone. It was built in 1895–98 to the designs of Richard Norman Shaw, and is similar to his New Scotland Yard building on the Thames embankment. To its left is the square tower of the James Street underground station; to the right, the dome of the colossal Custom House in Canning Place. Both were bombed in the Second World War and neither survives. On the skyline, construction of the Anglican Cathedral continues. Its state of completion suggests the photograph was taken in the mid-1920s.

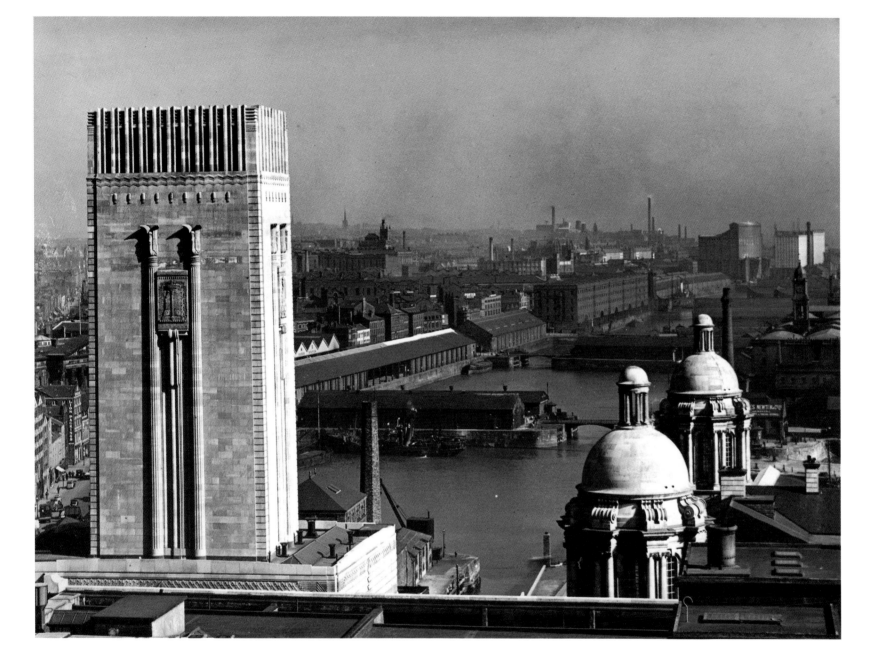

FROM THE ROOF OF THE LIVER BUILDING

Dominating this panoramic view is the square tower of the George's Dock Ventilation and Control Station of the first Mersey road tunnel, an elegant Art Deco structure designed by Herbert J. Rowse in 1932. The two domes on the right belong to the palatial former headquarters of the Mersey Docks and Harbour Board, today known as the Port of Liverpool Building. Beyond stretches a vista of the south docks, with their transit sheds and warehouses.

FLOODLIT GARDEN AT ST PHILIP NERI 1956
(RIGHT)

UPRIGHT AND HORIZONTAL
(OPPOSITE)

This unexpected piece of Mediterranean landscape, with its marble columns and formal pool, lies alongside the Roman Catholic church of St Philip Neri in Catharine Street. Known as the Spanish Garden, or El Jardín de Nuestra Señora, it was created in the early 1950s by the then parish priest, Dr John Garvin. The Christmas crib could be seen from the street by passers-by, framed in the arched gateway to the garden.

Hardman's description on the back of this photograph reads: 'While I was driving in a car past the western end of the Mersey Tunnel entrance in Liverpool, the "layabout" was observed. The question was, would he still be there by the time a place had been found to park the car and walk back? This took five minutes. Fortunately, he did not appear to have moved an inch, and seemed to have "passed out" completely. He had abandoned his newspaper, and the cigarette which had fallen from behind his ear can be seen on the ground.' The statue of King George V by William Goscombe John has since been moved from this position, and today overlooks the approach to the tunnel.

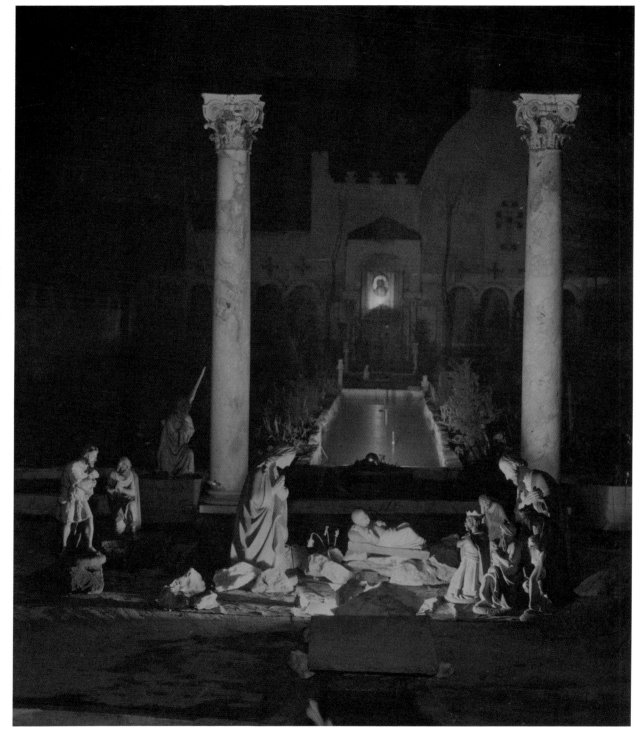

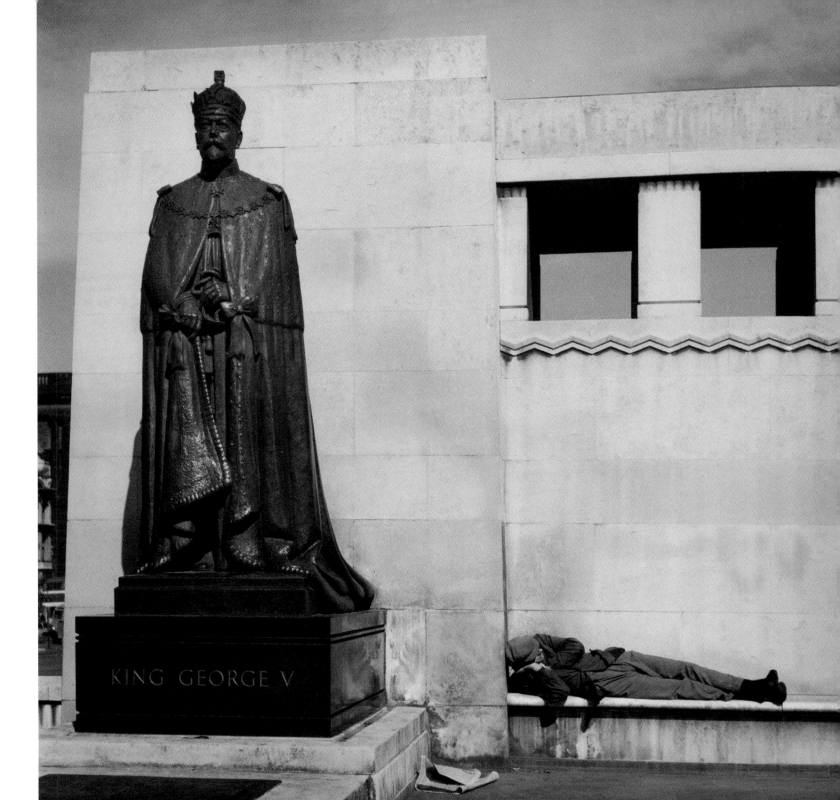

**LYCEUM, BOLD STREET
1973**

The Lyceum was built in 1800–02 and is one of the principal works of the neoclassical architect Thomas Harrison of Chester. It was designed to house two separate institutions: the Liverpool Library (a private facility for subscribers), and a newsroom, where businessmen had access to the newspapers that were their main source of commercial information. Threatened with demolition for a shopping development in the 1970s, it became the focus of a successful campaign by conservationists. It was carefully restored in the 1980s, when the soot-blackened stone shown in Hardman's photograph was cleaned.

BANK OF ENGLAND, CASTLE STREET

In the 19th century the Bank of England opened provincial branches in a handful of commercially important cities. Its first Liverpool home was a converted house in Hanover Street, then in 1846–48 it erected this majestic building, designed by the leading neoclassical architect C.R. Cockerell. The new location was chosen for its proximity to the Exchange Flags, the chief focus of business activity (see page 49). Following the arrival of the Bank, Castle Street developed into Liverpool's main financial thoroughfare. Much of the street was rebuilt in the second half of the century with other banks and insurance offices of great splendour, but Cockerell's Bank of England still holds its own.

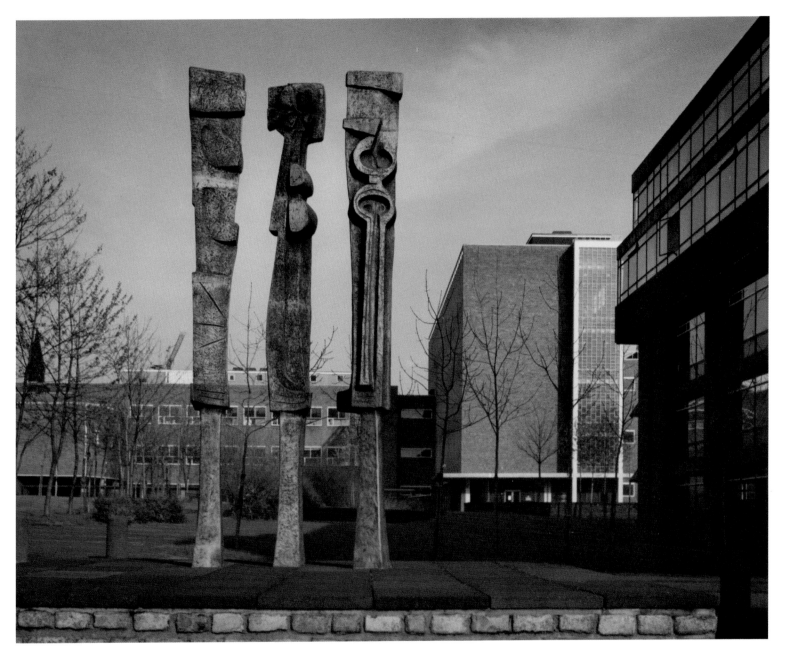

UNIVERSITY OF LIVERPOOL SCULPTURES 1972

The University of Liverpool expanded rapidly after the Second World War. It was a time of cultural ambition and optimism, when investment in new buildings was matched by the commissioning of public art. This work in cast aluminium was made by the sculptor Hubert Dalwood, for a site next to the new Physics building designed by Basil Spence.

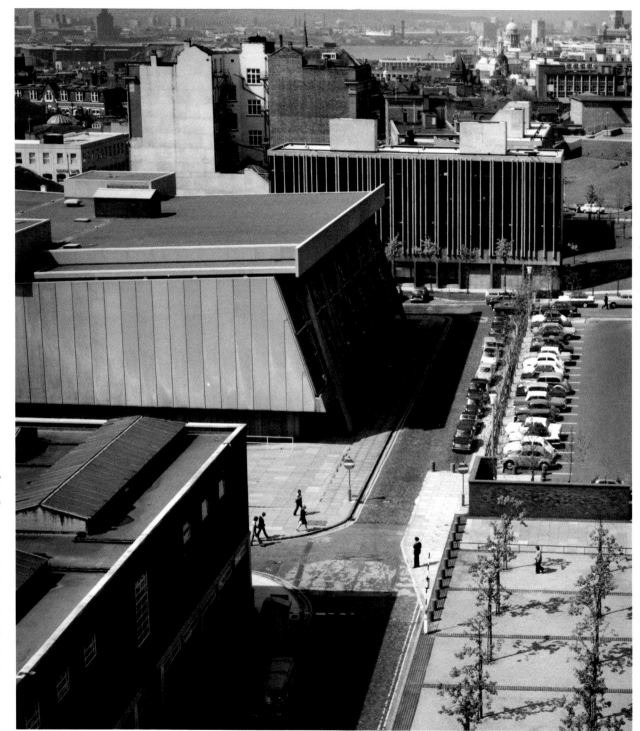

UNIVERSITY OF LIVERPOOL
SPORTS CENTRE
1972

The Sports Centre was the most controversial of the University's post-War buildings. Designed by Denys Lasdun and built between 1963 and 1966, it was notable for the completely glazed, inward-sloping façades on the north and south sides, lighting the sports hall and the swimming pool respectively. The north side shown in Hardman's photograph no longer survives: it was obliterated when an extension containing a second sports hall was added in 2003-04.

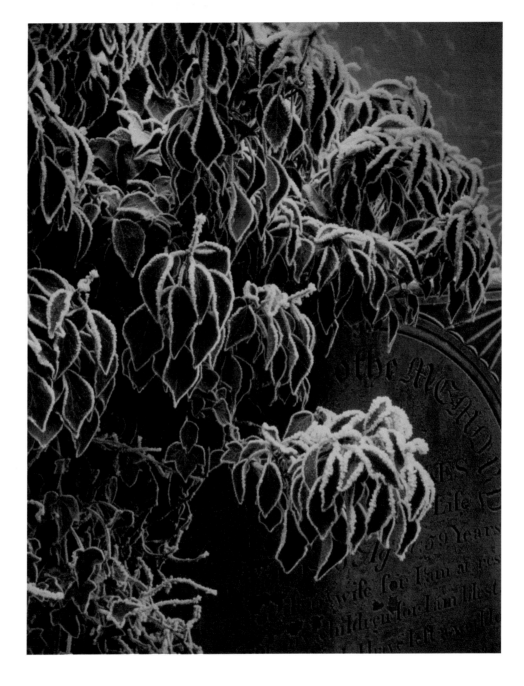

GRIEVE NOT
1960

Hardman's mother died in 1959, and this evocative photograph of a headstone in St James's Cemetery, taken the following year, has been linked with his bereavement. A euonymus bush, its leaves edged with hoarfrost, partly obscures the inscription, so that the name of the deceased is hidden. Hardman used gold chloride to give the print a bluish tone.

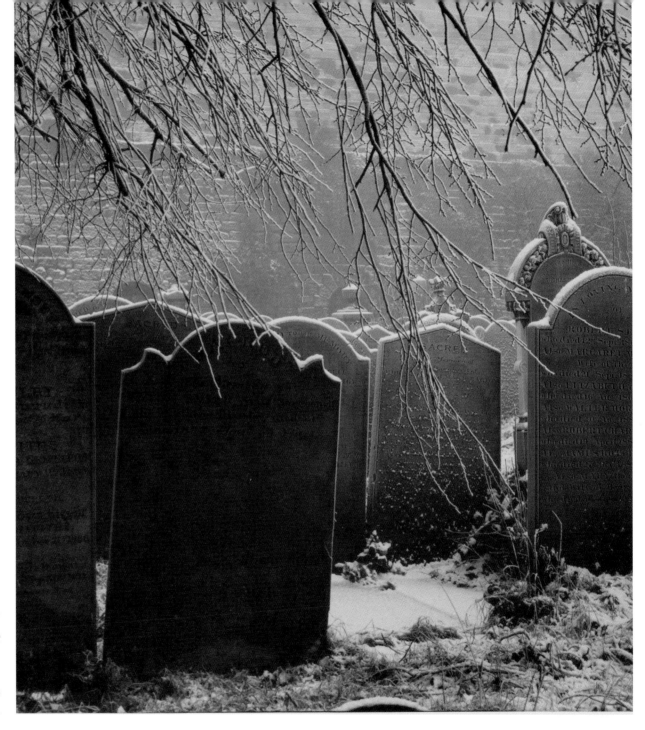

ST JAMES'S CEMETERY
EARLY 1960s

Another image of St James's Cemetery under snow (see opposite
and page 89).

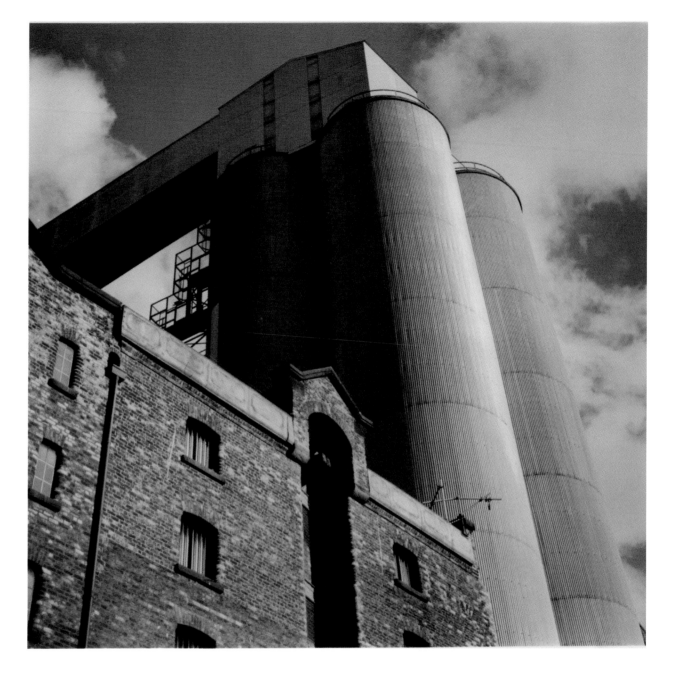

WAREHOUSE AND GRAIN SILO
1975

Different buildings for storage are contrasted in this dramatically composed image: the multi-storey warehouse, built in huge numbers in Liverpool in the 18th and 19th centuries; and the silo, used in the 20th century for commodities such as grain. The location is not recorded.

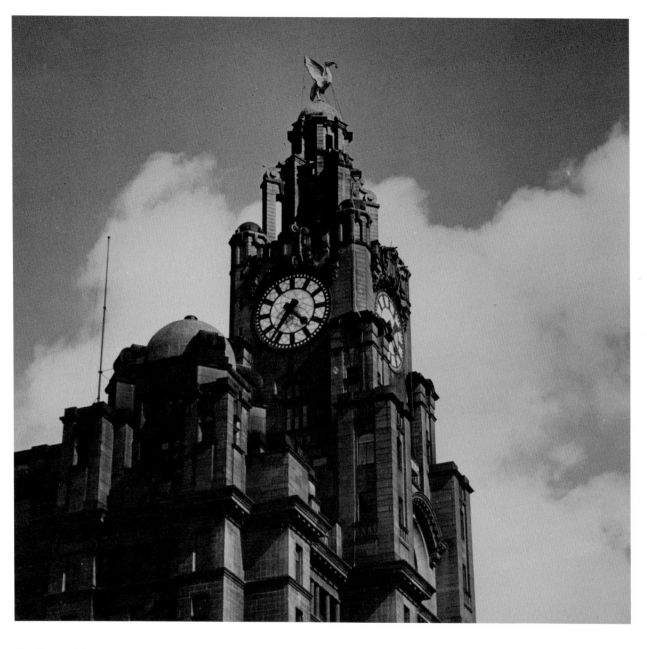

ROYAL LIVER BUILDING CLOCK TOWER

The liver bird is the historic symbol of Liverpool. It was also the emblem of the Royal Liver Friendly Society (now Royal Liver Assurance), and its most famous incarnations are the pair that perch on the twin towers of the company's headquarters, the Royal Liver Building. Made of sheet copper on a steel frame, they were originally gilded. On 22 June 1911, the coronation day of King George V, the newly installed clock in the western tower was set in motion by the Society's chairman, at exactly the moment the crown was placed on the monarch's head. The clock was named 'Great George' to mark the occasion.

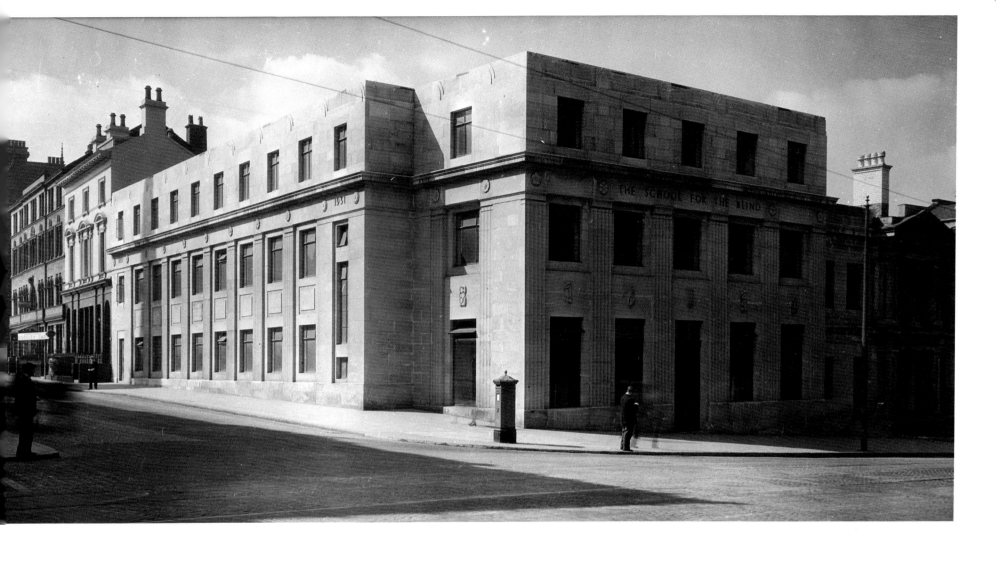

SCHOOL FOR THE BLIND
1932

The School for the Blind moved from London Road to new premises in Hardman Street in 1851. In 1930 the school chapel in the form of a Greek temple at the corner of Hope Street was demolished and replaced with this extension, designed by the Liverpool-trained architects Minoprio & Spencely. Its shape echoes the vanished chapel, but its style is a simplified, squared-off classicism, American in inspiration. The lighting of Hardman's photograph emphasises the building's crisp lines. Across the front are carvings by the sculptor John Skeaping, illustrating activities at the school such as brush-making, basketry, knitting and reading Braille.

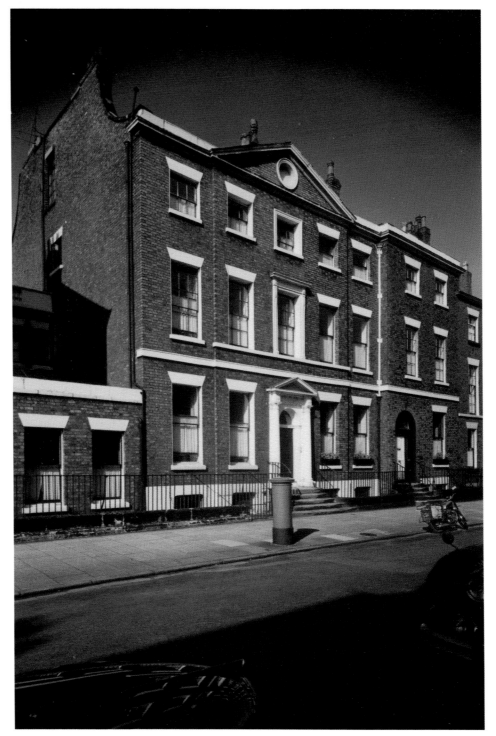

GLADSTONE'S HOUSE, 62 RODNEY STREET

John Gladstone, a merchant from Leith who made his fortune in Liverpool, built this house for himself in 1792–93. It was here that his son William Ewart Gladstone, four times Prime Minister, was born in 1809. At first the house stood alone in its own grounds. Later, when the Gladstones decided to move out of town, the neighbouring plots were built on and it became part of a terrace.

MONUMENT, ST ANDREW'S CHURCH, RODNEY STREET
1972

Built in the 1820s for the Scottish Presbyterians, St Andrew's stands at the opposite end of Rodney Street from Hardman's studio. The impressive granite pyramid in the churchyard commemorates William Mackenzie (1794–1851), the railway contractor who constructed the tunnel from Edge Hill to Lime Street Station in 1832–35. He went on to make a fortune building railways in both France and Britain.

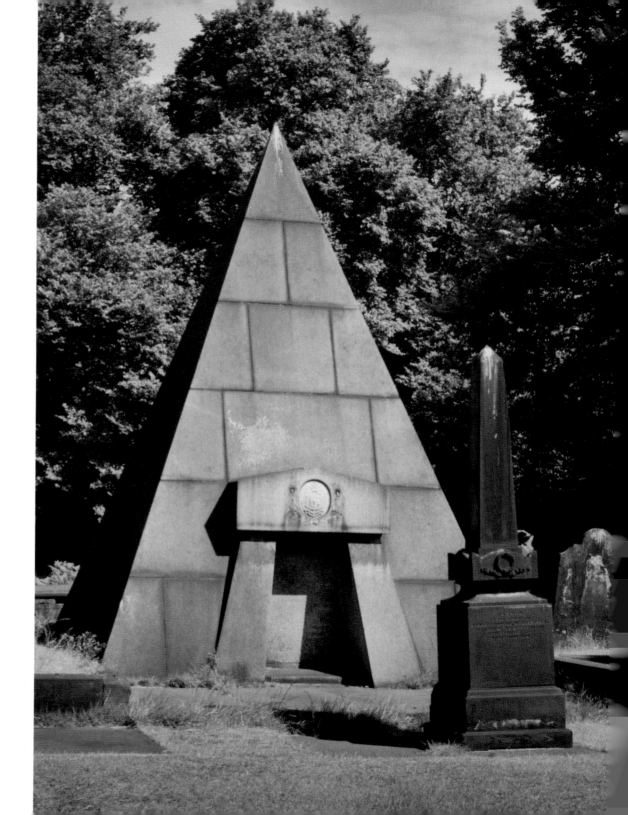

HUSKISSON MEMORIAL, ST JAMES'S CEMETERY 1971

This temple-like building was designed by John Foster Junior and erected in 1833–34. It marks the grave of William Huskisson, MP for Liverpool, who was fatally injured by Stephenson's Rocket at the opening of the Liverpool and Manchester Railway on 15 September 1830 – this was the first railway fatality. The layout of the cemetery, which lies in a former quarry, was also designed by Foster. He shaped the east side into a series of ramps and terraces, giving access to catacombs with arched entrances. Shortly before Hardman took this picture the cemetery was cleared of most of its gravestones and transformed into a garden.

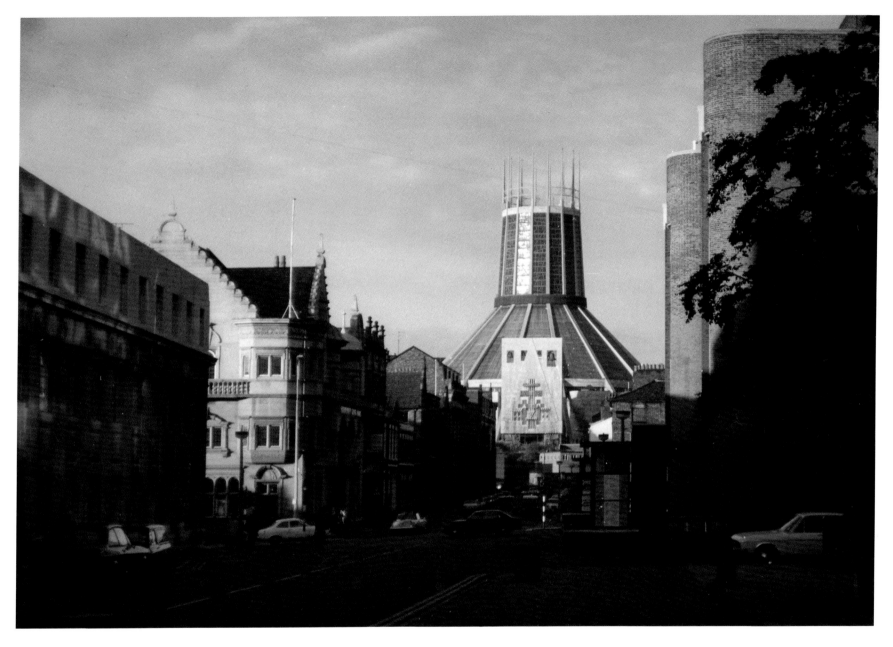

HOPE STREET AND THE ROMAN CATHOLIC CATHEDRAL
1970s

The Metropolitan Cathedral of Christ the King (see also opposite), with its crown-topped tower and its cliff-like entrance that doubles as a belfry, makes a dramatic termination to Hope Street. The street has other architectural landmarks too. Behind the tree on the right is the Philharmonic Hall, a distinguished Art Deco building designed by Herbert J. Rowse and opened in 1939. On the opposite side, the corner building with projecting windows and decorative gables is the famous Philharmonic Hotel of c. 1898–1900. Designed by Walter W. Thomas, it is one of the most lavishly decorated Victorian pubs in the country.

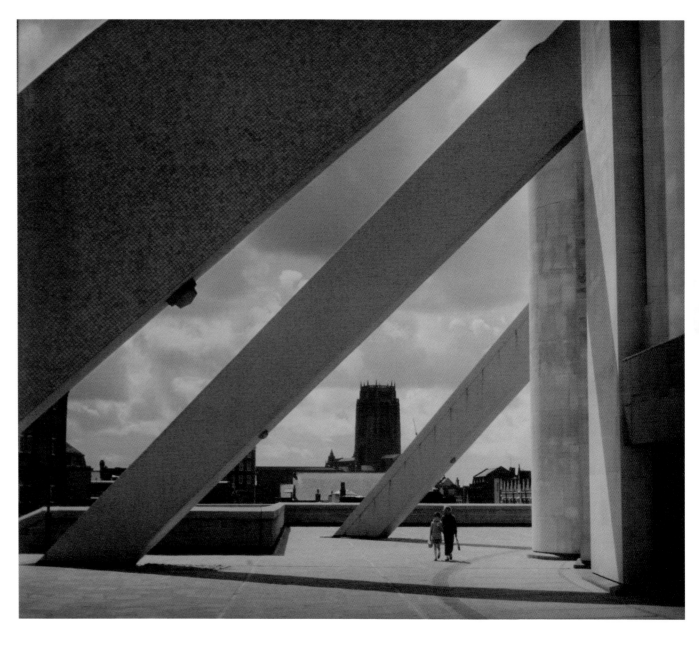

LIVERPOOL'S TWO CATHEDRALS
1969

The view is from outside the Roman Catholic cathedral, designed by Frederick Gibberd and completed in 1967. The building is circular in plan, its conical roof and central tower supported by sixteen radiating diagonal buttresses, like the guy ropes of a tepee. In Hardman's photograph, two of the buttresses frame a distant view of the very different Anglican Cathedral, at the opposite end of Hope Street. Its dark, Gothic bulk contrasts with the simple shapes and bright surfaces of Gibberd's building, summing up the architectural changes that transformed Liverpool – and other British cities – in the 1960s.

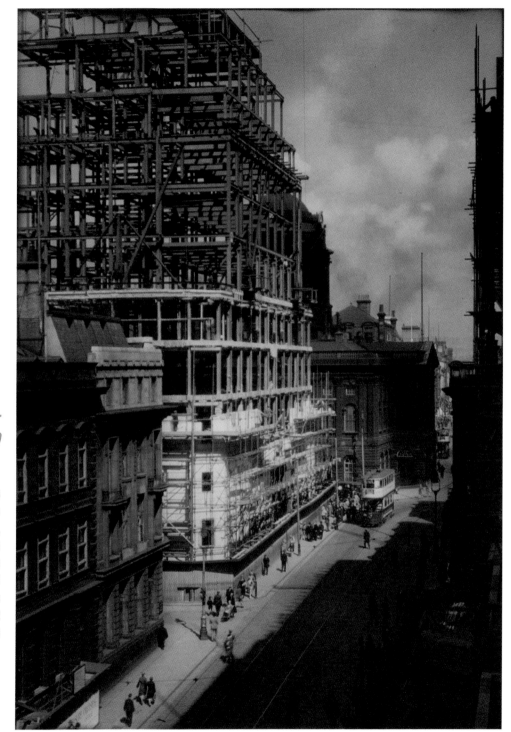

WATER STREET
1929

The large building under construction is the headquarters of Martins Bank, its steel frame towering above the dome of the Georgian Town Hall behind. The bank was designed by Herbert J. Rowse, Liverpool's leading architect in the 1920s and 30s. He trained at the University of Liverpool, then worked in North America before returning to his native city. Contemporary American architecture had an enormous influence on his work, and the soaring bulk of Martins Bank would be quite at home in Manhattan. Just visible on the right is the scaffolding of India Buildings, an even bigger American-style office block that Rowse was working on at the same time.

THE STRAND AND WATER STREET
1933

This illustrates how the increasing size of commercial buildings transformed Liverpool's business district during Hardman's lifetime. In the middle is Drury Buildings, Water Street, a typical office block of the 1850s. It is completely dwarfed by its newer neighbours: to the left, Tower Buildings of 1906, designed by Walter Aubrey Thomas, architect of the Royal Liver Building; to the right, West Africa House of about 1920, by Briggs, Wolstenholme & Thornely; and behind, India Buildings, completed in 1930, by Arnold Thornely and Herbert J. Rowse. These and other tall buildings nearby give this part of Liverpool an unmistakeably transatlantic feel.

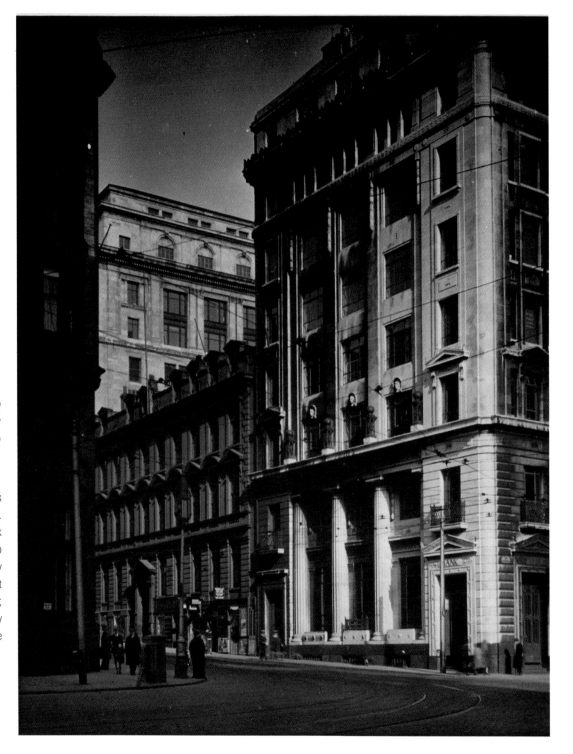

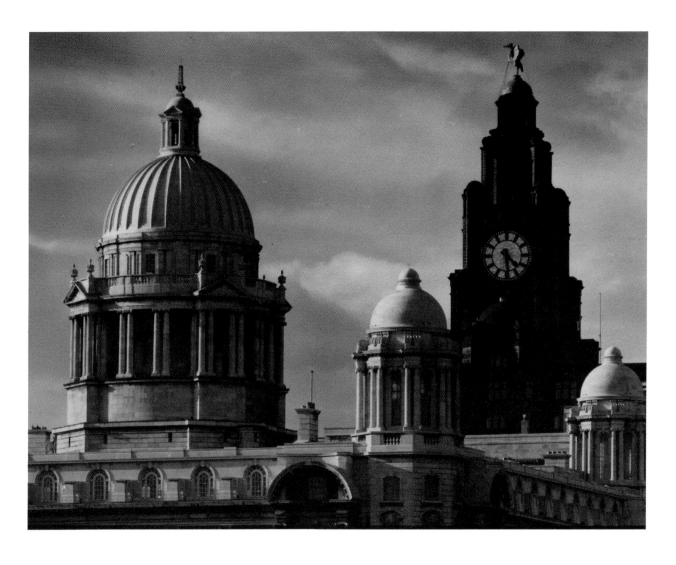

PORT OF LIVERPOOL BUILDING AND ROYAL LIVER BUILDING

The Port of Liverpool building was the first of the Pier Head trio to be built, in 1903-7. It served as the palatial headquarters of the Mersey Docks and Harbour Board. When the corresponding site at the north end of the Pier Head was offered for sale, the Board hoped that a matching building would be erected there. They were horrified when instead the Royal Liver Friendly Society overshadowed them with its mini skyscraper. Hardman's vantage point for this shot is unclear, but it may have been the nearby pump house of the Mersey Railway tunnel at Mann Island.

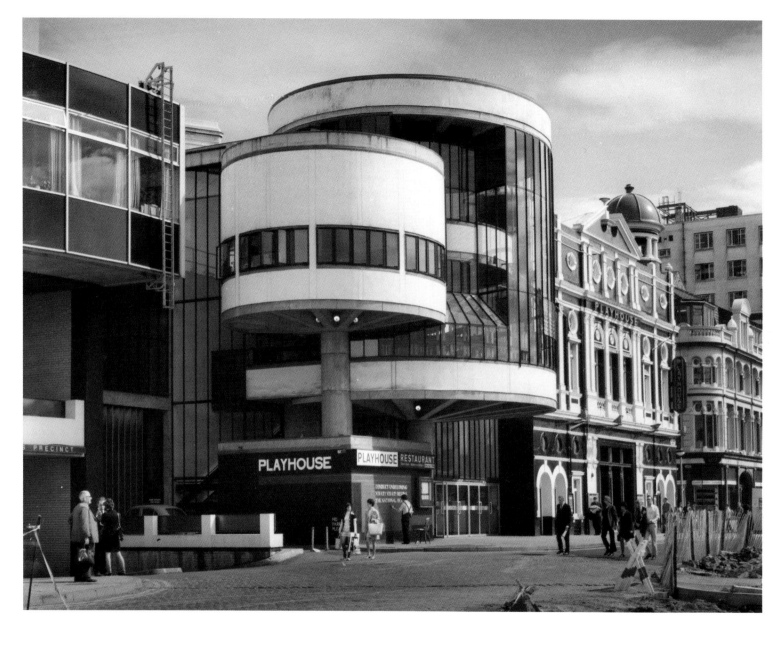

PLAYHOUSE THEATRE, WILLIAMSON SQUARE 1972

The Playhouse was a Victorian music hall, which in 1910 became home to the Liverpool Repertory Theatre. In 1968 a striking extension designed by Hall, O'Donahue & Wilson was completed: two interlocking drums of concrete and glass, cantilevered from central columns, contain box office, foyer spaces and bars. Like the Roman Catholic Cathedral, it was an architectural symbol of the fashionable, forward-looking Liverpool of the 1960s.

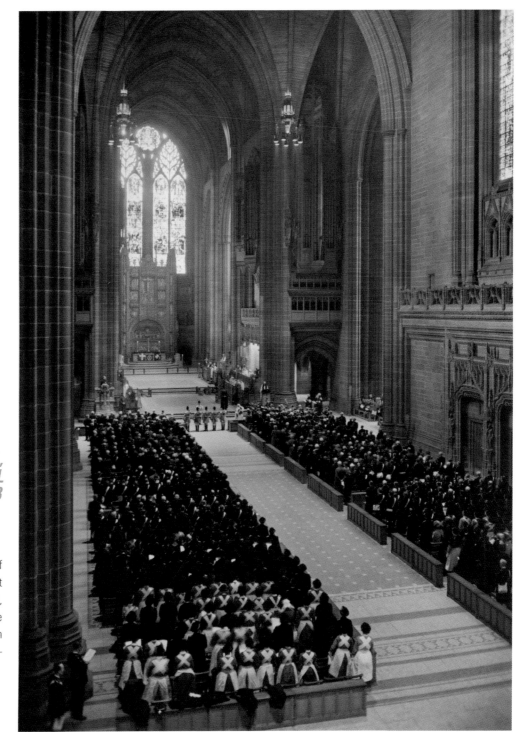

COMMEMORATION SERVICE, LIVERPOOL CATHEDRAL 1953

The occasion recorded here is the annual commemoration service of the Order of the Hospital of St John of Jerusalem, held for the first time in Lancashire in 1953. In a note on the back of the print, Hardman described the exact moment shown: 'The State Trumpeters are playing immediately before the wreath – in the form of the Red Rose of Lancaster, held by the two nurses on the right – was laid on the Cenotaph'.

ST LUKE'S CHURCH FROM THE SOUTH EAST 1973

The foundation stone of St Luke's was laid in 1811, though the church was not completed until 1831. John Foster Senior and his son John Foster Junior, successive Corporation Surveyors, were in charge of the project, but another anonymous architect may have been behind the splendid Gothic design. The timber interior was destroyed in the May blitz of 1941, since when St Luke's has been known as 'the bombed-out church' and has come to be regarded as an unofficial war memorial. Hardman's photograph was taken soon after the stonework had been cleaned.

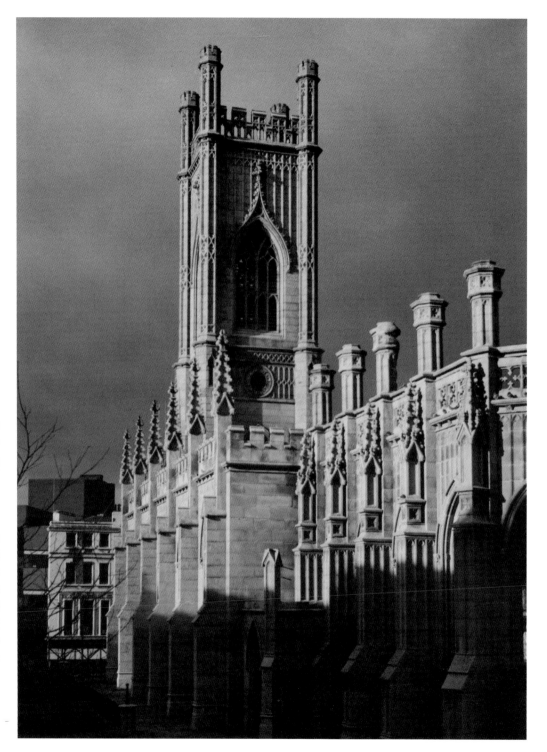

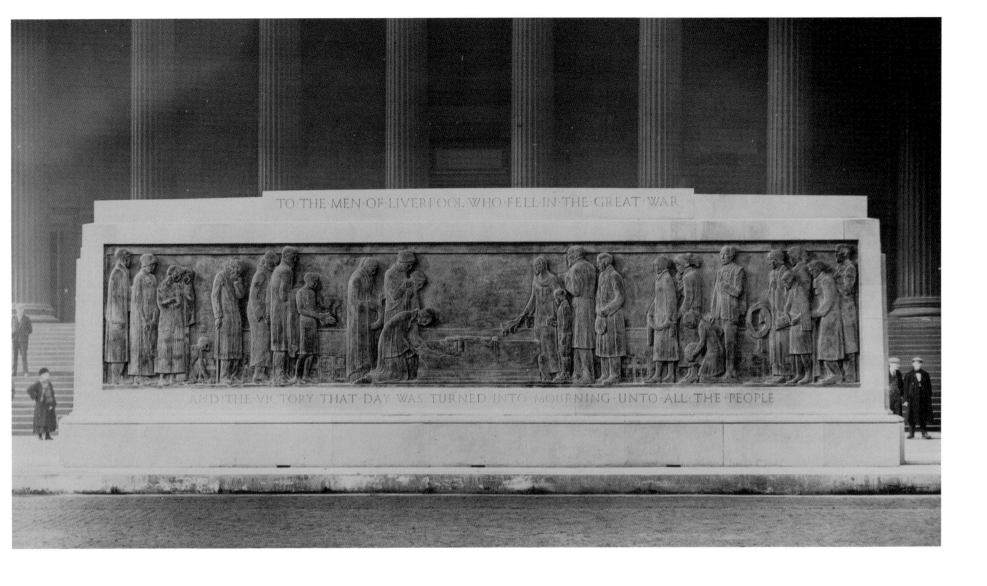

TO·THE·MEN·OF·LIVERPOOL·WHO·FELL·IN·THE·GREAT·WAR

AND·THE·VICTORY·THAT·DAY·WAS·TURNED·INTO·MOURNING·UNTO·ALL·THE·PEOPLE

LIVERPOOL CENOTAPH
1930

The cenotaph stands on the plateau between St George's Hall and Lime Street. It was designed by Lionel Budden, associate professor at the Liverpool School of Architecture, and the long panels of relief sculpture on each side were made by the local sculptor Herbert Tyson Smith. It is one of the most arresting war memorials in any British city. Hardman's photograph, in which the newly completed monument stands out brightly against the smoke-blackened portico of St George's Hall, shows the relief on the east side. It represents a crowd of mourners of all ages in everyday dress, standing before a military cemetery with gravestones receding to infinity.

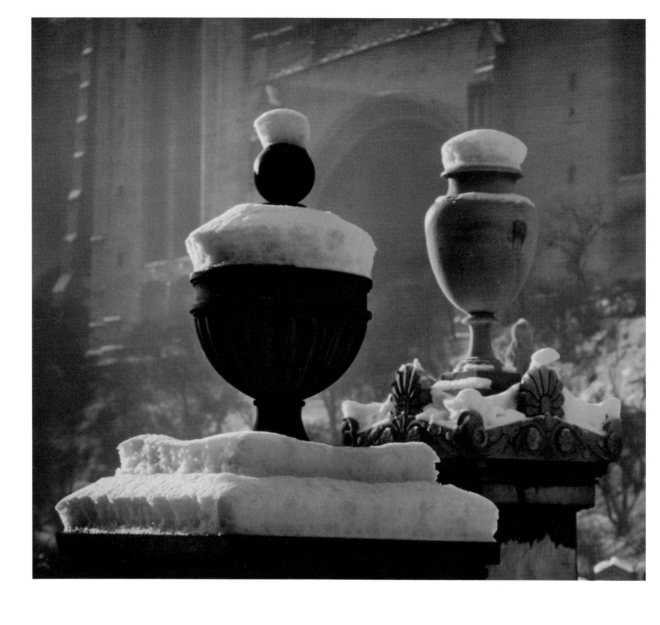

SNOW-CAPPED URNS
1955

Hardman enjoyed the transforming effect of snow on the city, especially the contrast between its powdery whiteness and Liverpool's soot-blackened stone. This shot was taken in St James's Cemetery, below the cliff-like east face of the Anglican Cathedral. The cemetery was laid out in 1827–29 in a deep, rocky hollow that had formerly been a quarry. Many of Liverpool's notable citizens were buried here (see also page 79).

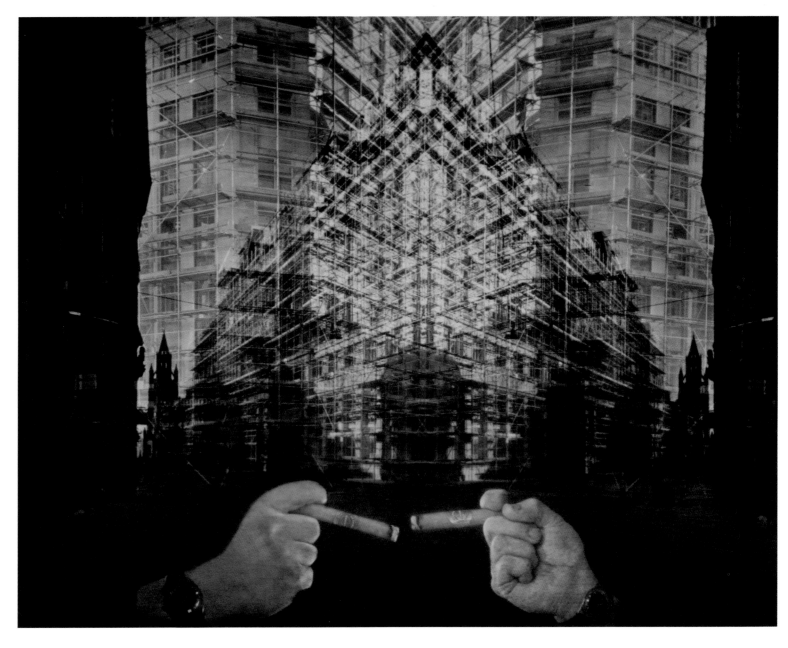

This image apparently dates from the 1950s, when the post-War transformation of central Liverpool started to get under way. It is based on a view looking down Chapel Street, dominated by the new Exchange Buildings, still covered with scaffolding. These were begun in the 1930s, but construction was interrupted by the War. Hardman created the picture by combining four different negatives: mirror images of the buildings are superimposed on each other, so that they seem fused together, while in the foreground the hands of a pair of cigar-smoking businessmen celebrate the 'merger'.

PROPERTY MERGER

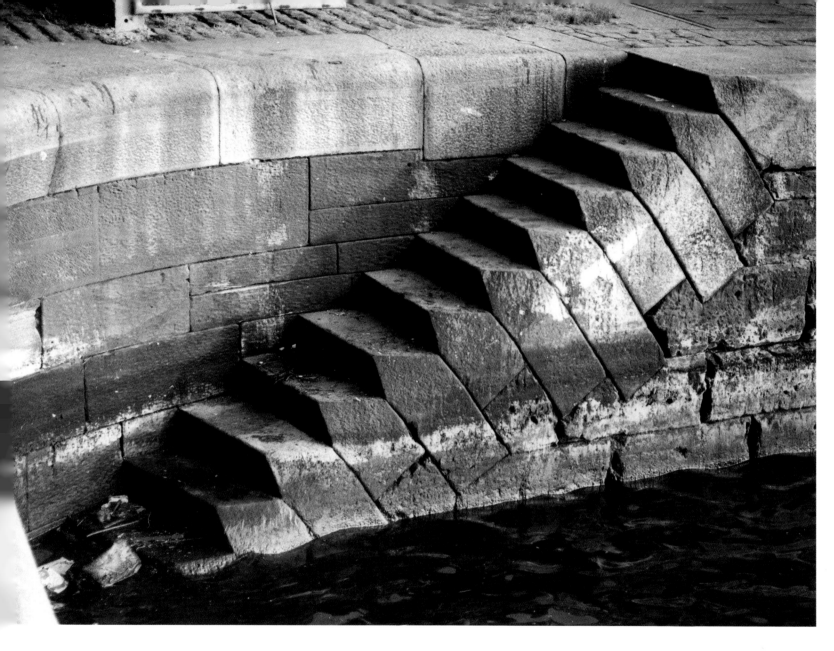

**QUAYSIDE STEPS
1970s**

The Liverpool docks built under the supervision of Jesse Hartley, Dock Engineer from 1824 to 1860, are remarkable for the quality of their stonework. Granite was brought by sea from south-west Scotland where the Mersey Docks and Harbour Board leased a quarry, and was worked with great skill and precision by Hartley's masons. The resulting walls look – and are – formidably strong: when the cotton merchant George Holt visited Hartley's new Albert Dock in 1845, he wrote in his diary 'The construction is for eternity, not time.'

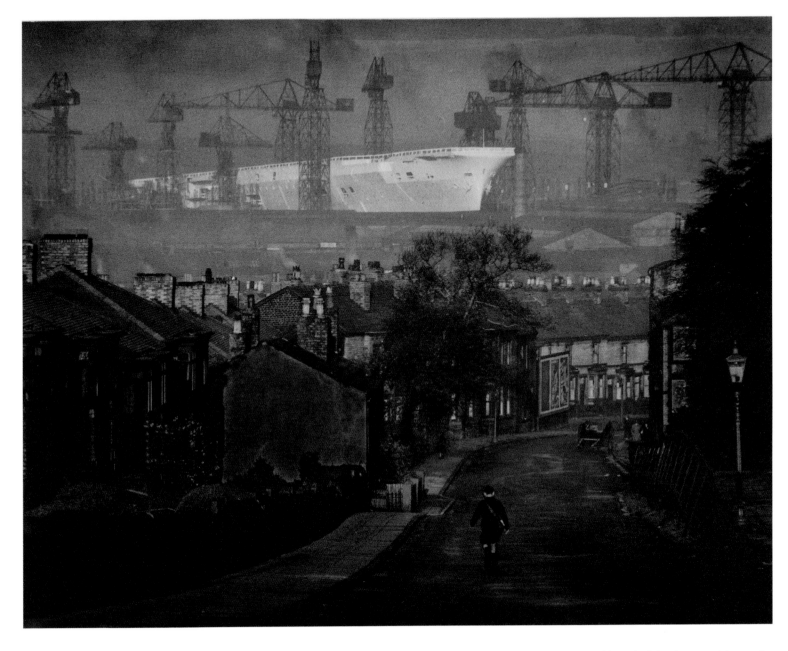

THE BIRTH OF THE ARK ROYAL
1950

This is probably Hardman's most famous picture. Taken on 1 April 1950, it shows HMS Ark Royal shortly before the great ship was launched from Cammell Laird's yard. Surrounded by cranes, her huge bulk seems to float above the Birkenhead rooftops. Hardman made several changes to the negative to achieve exactly the result he wanted. By darkening the gable end of the foreground house, for instance, he focused attention on the ghostly white-painted hull. 'I was trying to recreate what I had seen,' he said later, 'to produce an effect, and anything that goes against the effect I want, I rule out.'

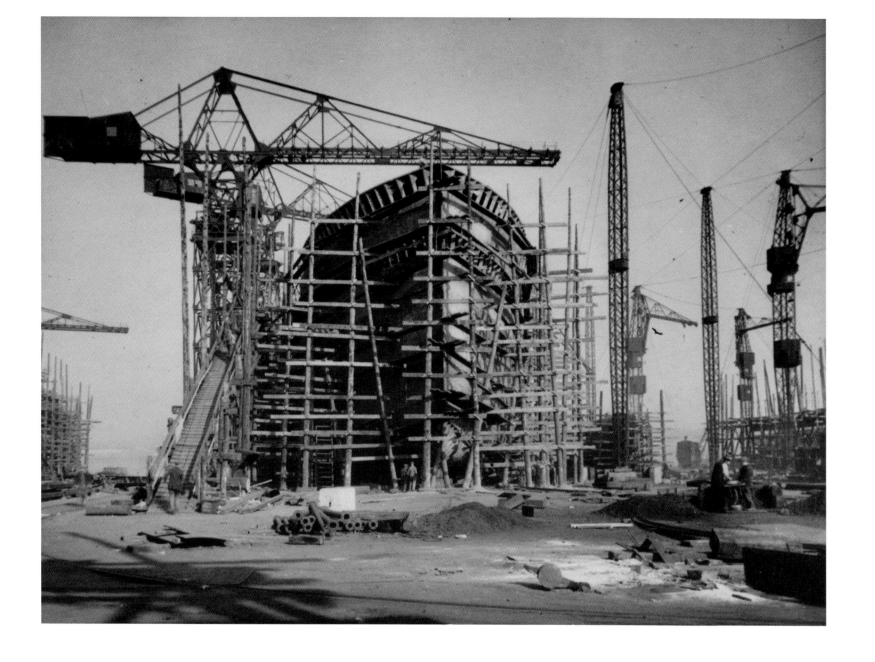

WOODEN SCAFFOLDING 1930

This picture shows a ship under construction in Cammell Laird's yard, Birkenhead. Remarkably for its date, the scaffolding around the hull is made of timber – this was perhaps the last vessel to be built at Laird's using wooden scaffolding. The low viewpoint emphasises the immense height of the ship, and the even taller crane.

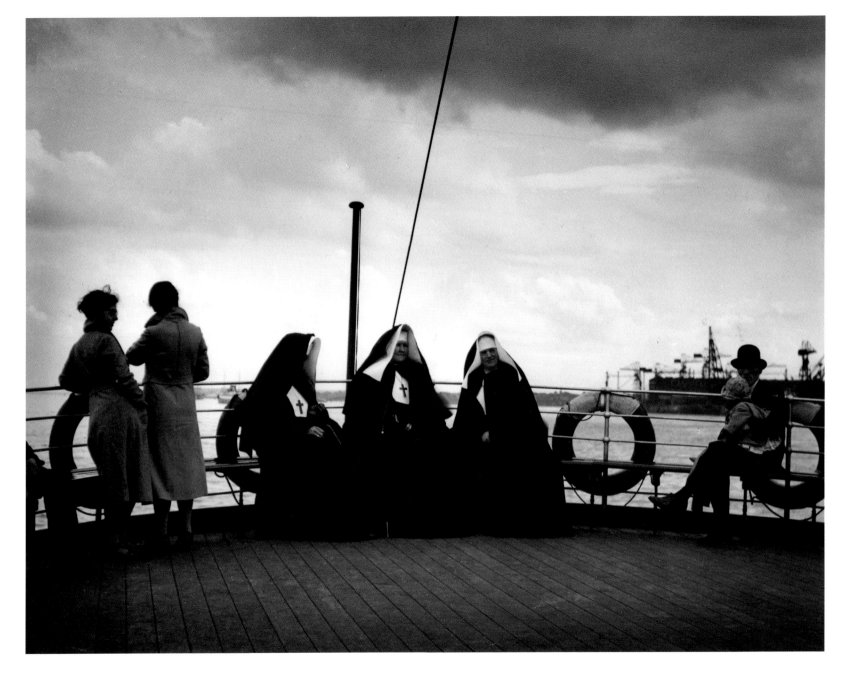

NUNS ON THE FERRY

Seated on the deck of the cross-river ferry between Liverpool and Birkenhead, the nuns make a picturesque contrast with their fellow passengers. Hardman's attention seems to have drawn different reactions from each — the one on the left remains self-contained, but her companion on the right appears a little more responsive.

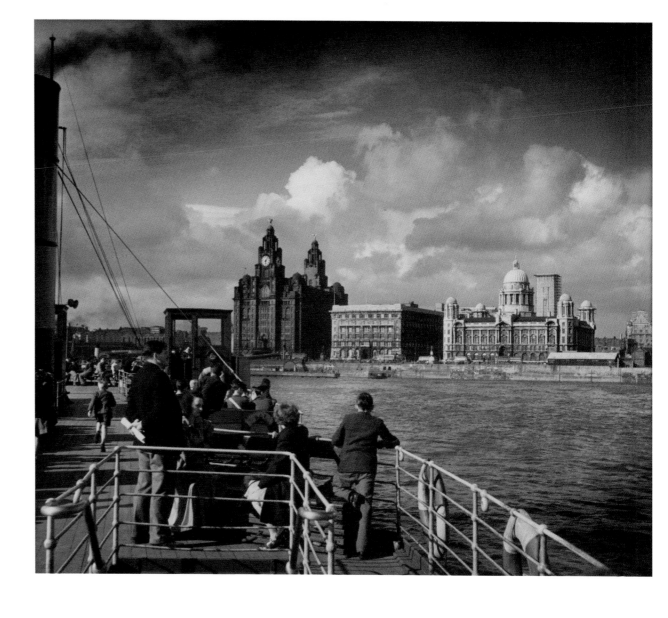

SCHOOLBOYS ON THE FERRY

The Pier Head trio – the eccentric Royal Liver Building on the left, the majestic Port of Liverpool Building on the right, and the elegant Cunard Building in the middle – were designed to be seen from the water, and locals have always been able to enjoy this thrilling view from a Mersey ferry. The sight of the three great buildings drawing closer makes even the short river crossing feel like an important voyage. Hardman's photograph shows how the view inevitably fixes the attention of the passengers, and he subtly emphasises the sunlit buildings, contrasting them with the dark, overarching smoke plume of the ferry.

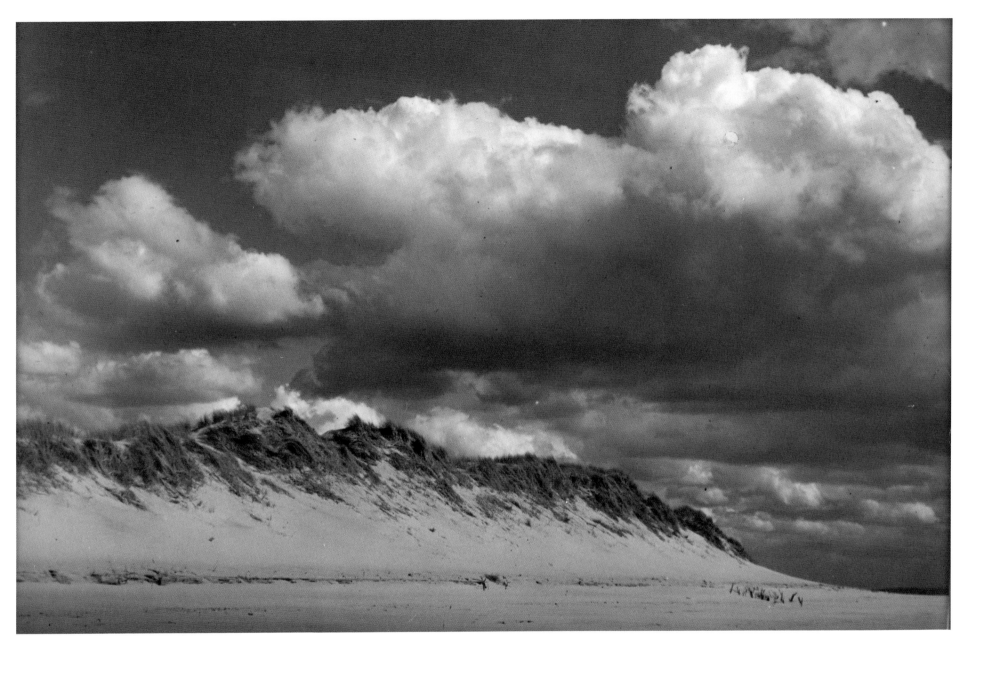

FORMBY DUNES

Beyond the docks and the commuter suburbs, the coast north of Liverpool changes dramatically. From 1929 to 1932 Hardman lived at Formby, midway between Liverpool and Southport, where miles of sand dunes and windswept beach face the Irish Sea. Much of this coastline is now owned and managed by the National Trust.

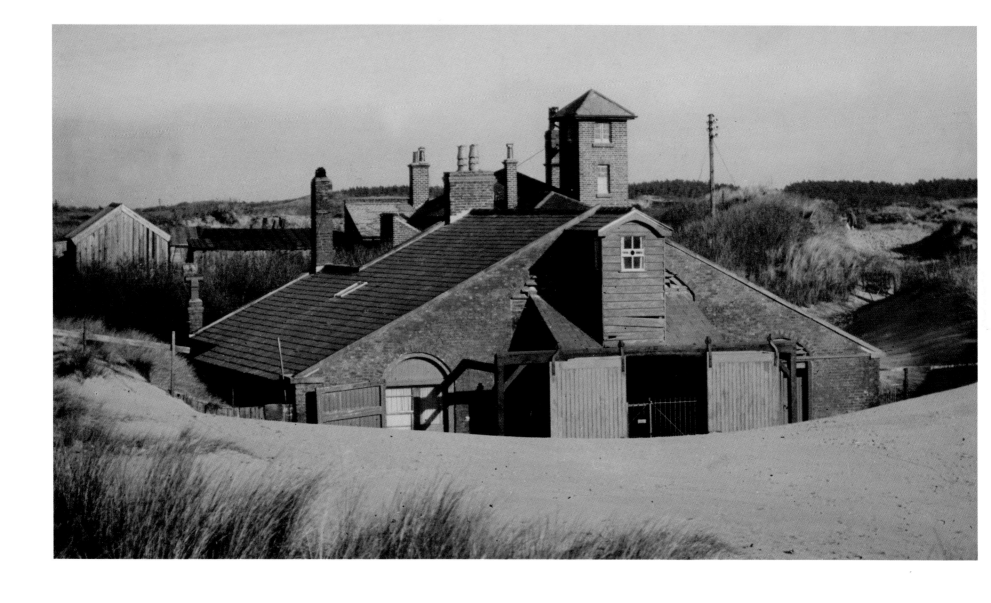

OLD LIFEBOAT STATION, FORMBY 1930

Formby Point is about ten miles north of Liverpool, facing the Irish Sea and the approach to the river Mersey. It is the site of what is believed to have been the first lifeboat station in Britain. Certainly the station was in existence by 1776: a chart published in that year describes 'a boathouse, and a boat kept ready to save lives from vessels forced on shore on that coast', and records that 'a guinea, or more, reward is paid by the Corporation for every human life that is saved by means of this boat'. The original 18th-century building was later reconstructed, and Hardman's photograph shows how it appeared in 1930. Only traces of the foundations survive today.

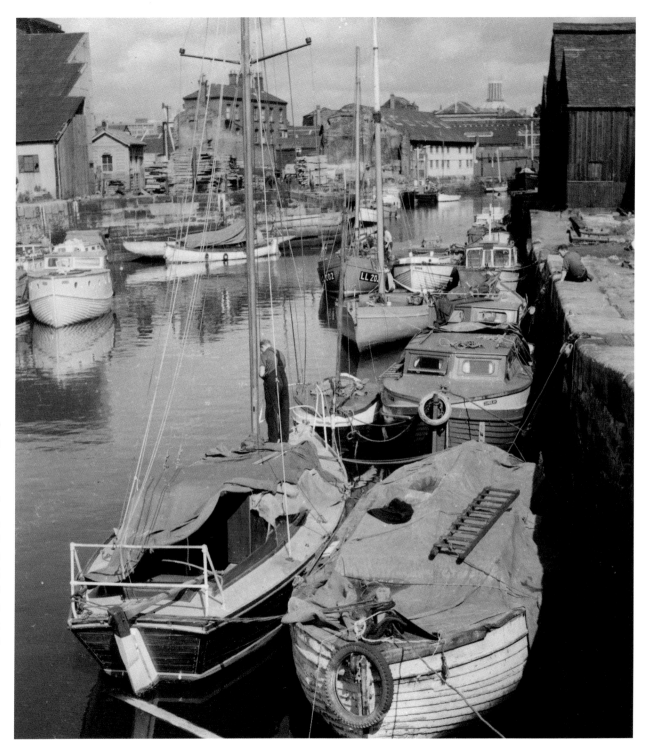

SMALL VESSELS IN DUKE'S DOCK
1967

Duke's Dock is named after Francis Egerton, 3rd Duke of Bridgewater. Lying immediately south of what is now Albert Dock, its earliest part was completed in 1773. It enabled the duke to transport goods between Liverpool and Manchester via his Bridgewater Canal, which connected with the Mersey upstream at Runcorn. The dock's small scale was suited to canal barges and flats rather than sea-going vessels. By the time this photograph was taken, the general decline of inland water transport had made it something of a backwater. The newly completed Roman Catholic cathedral is prominent on the skyline.

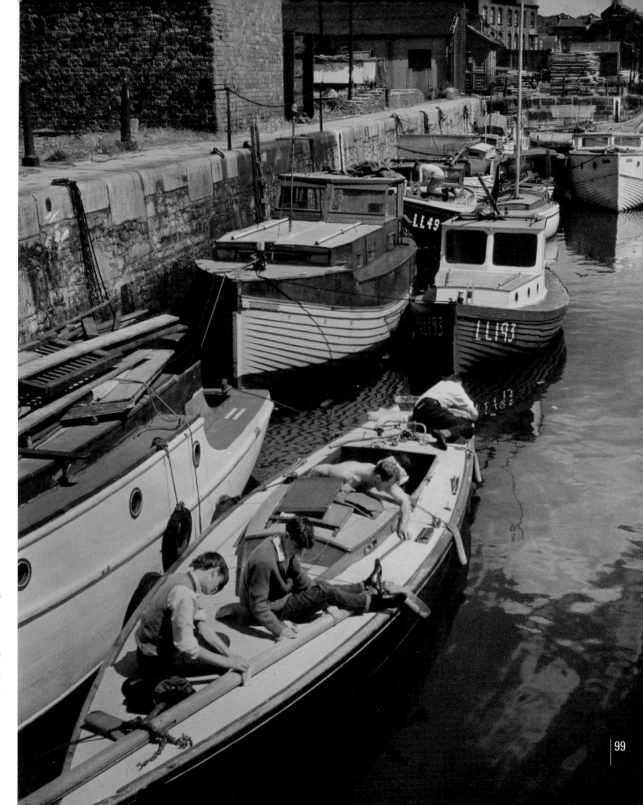

SANDING THE MAST, DUKE'S DOCK

Duke's Dock in the mid-20th century has been described as a sort of graveyard for derelict boats, but Hardman's photograph records a more cheerful scene of quaint variety and peaceful, leisurely activity.

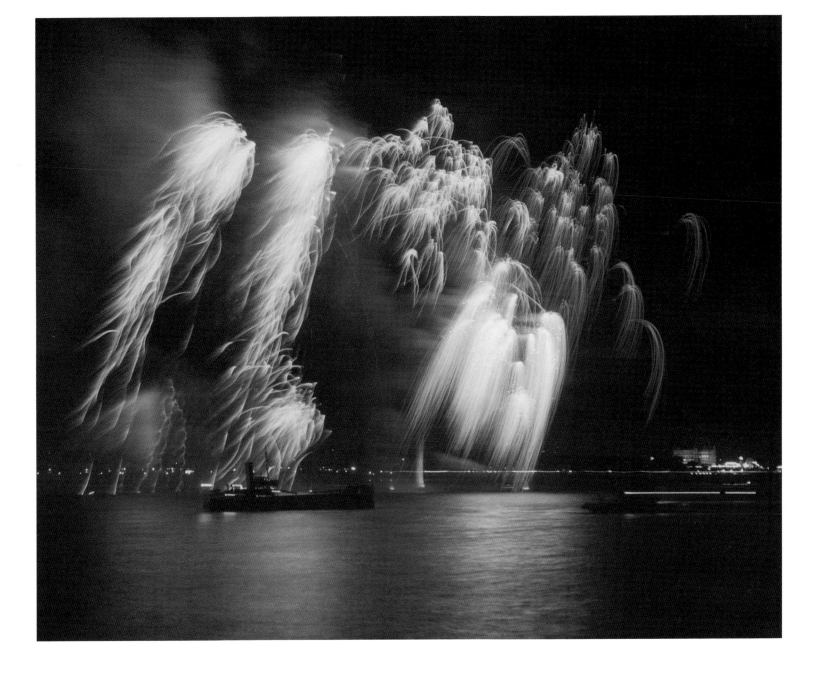

FESTIVAL FIREWORKS
OVER THE MERSEY

This firework display on 26 July 1951 was part of Liverpool's celebrations for the Festival of Britain, a national event intended to lift post-War gloom and raise the country's spirits. Hardman's vantage point was near Canada Dock, looking towards New Brighton. The picture won him second prize in the *Liverpool Daily Post's* Festival Photograph Competition.

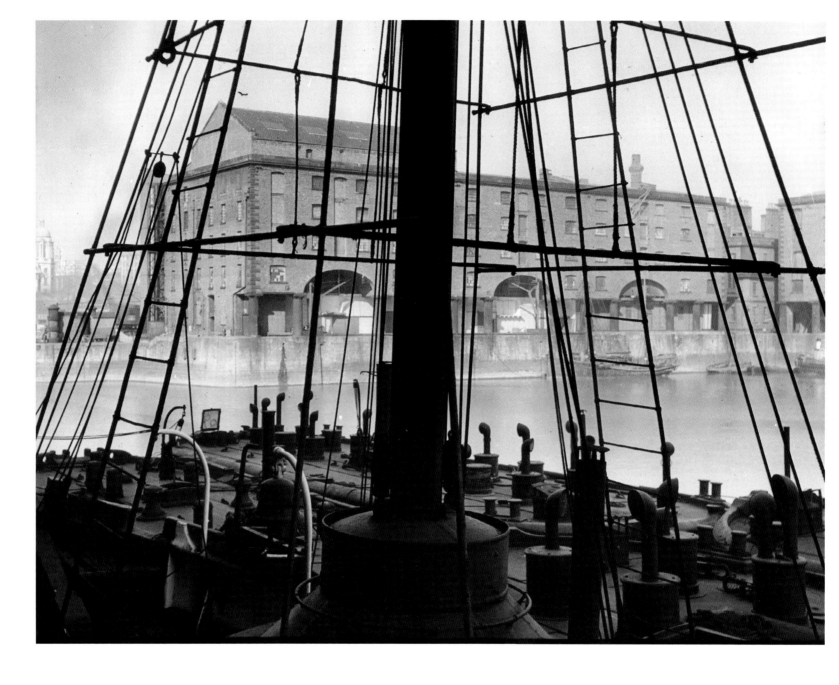

SPIDER'S WEB, ALBERT DOCK

The complicated rigging of the boat in the foreground frames a view of the north warehouse block, now occupied by the Merseyside Maritime Museum.

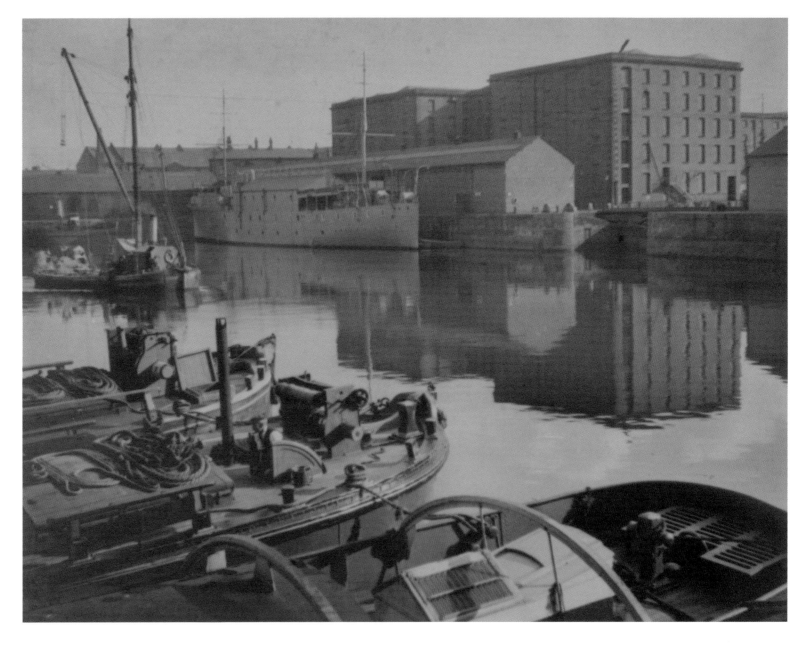

ALBERT WAREHOUSE FROM SALTHOUSE DOCK

This picture is undated, but it must have been taken before 1932, when it appeared in a publication to mark the Eighth Advertising Association Convention held in Liverpool. Originally constructed in the 18th century, Salthouse Dock was remodelled and enlarged in the 1840s by the dock engineer Jesse Hartley, in connection with his new Albert Dock. Designed for sailing ships, these docks quickly became obsolete with the advent of large ocean-going steam vessels, though the warehouses continued in profitable use for more than a century. In Hardman's photograph Salthouse Dock is occupied by small boats, and has a far from bustling appearance.

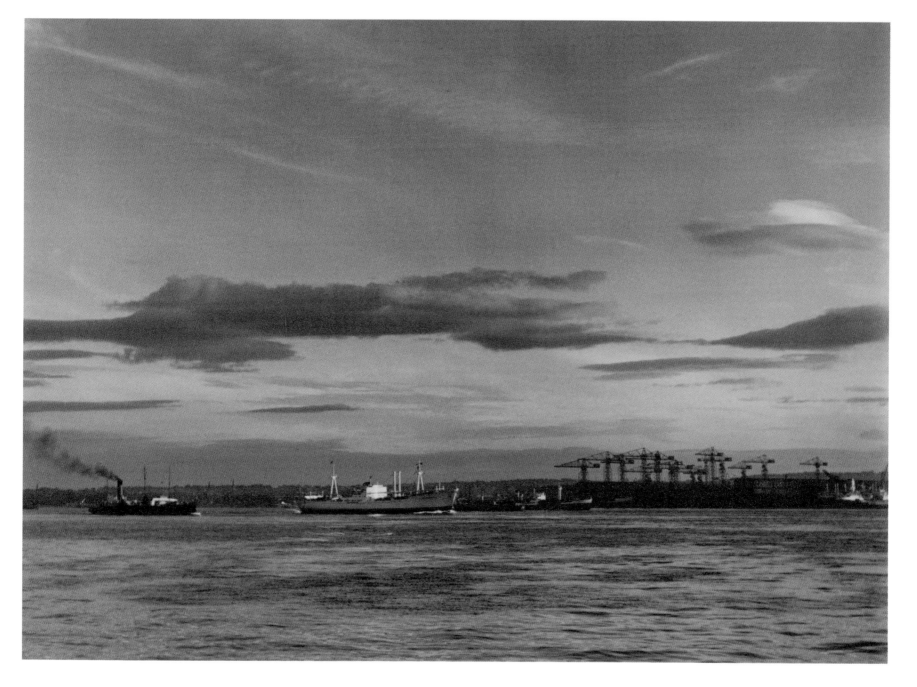

FREIGHTERS PASSING CAMMELL LAIRD

The distinctive forest of cranes identifies this as a view across the Mersey to Cammell Laird's ship yard, but the real subject is the dramatic sky.

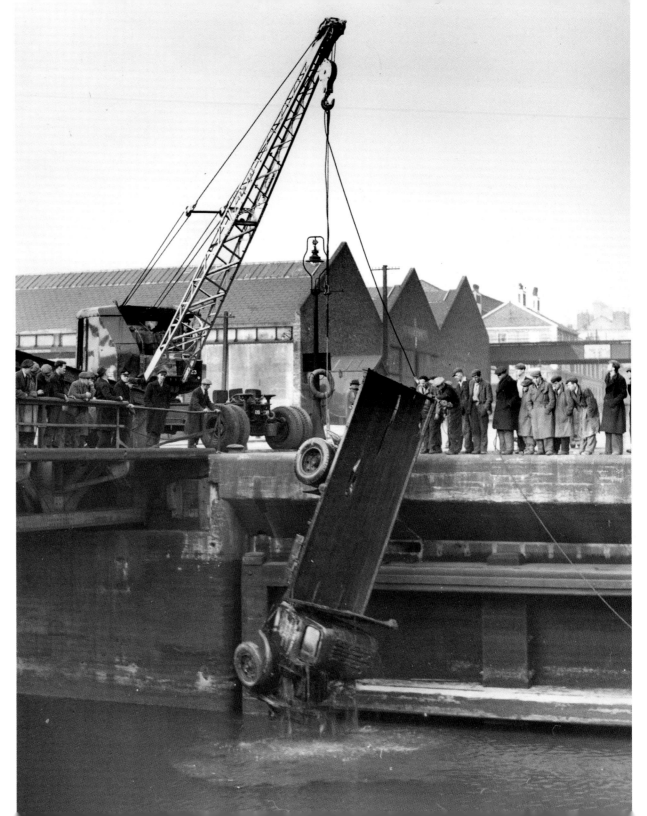

CRANE REMOVING LORRY FROM DOCK

The circumstances surrounding this striking photograph are not known, but it presumably shows the aftermath of an accident. The location is not recorded either, but the crane is probably standing beside the swing bridge over the passage between Queen's Dock and Coburg Dock, with the Overhead Railway in the background and Stanhope Street stretching away uphill.

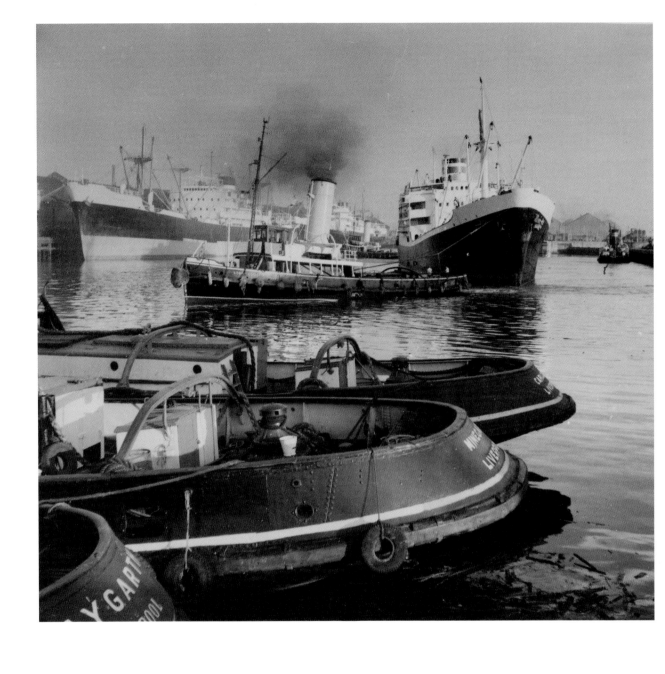

TUGS, BRUNSWICK DOCK Hardman contrasts the low, smoke-belching tugs in the middle distance and foreground with the bigger, more graceful ships behind.

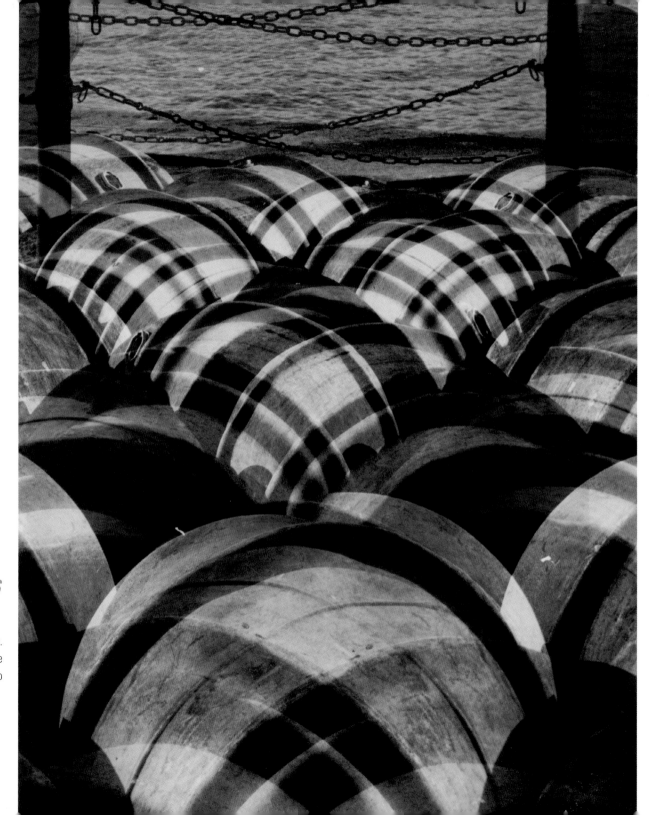

TARTAN BARRELS

It is not clear how Hardman made this bizarre, almost comic image. A photograph of barrels lying crowded together on the dock side seems to have been overprinted with the same image in reverse, so that the barrels look like plump tartan cushions.

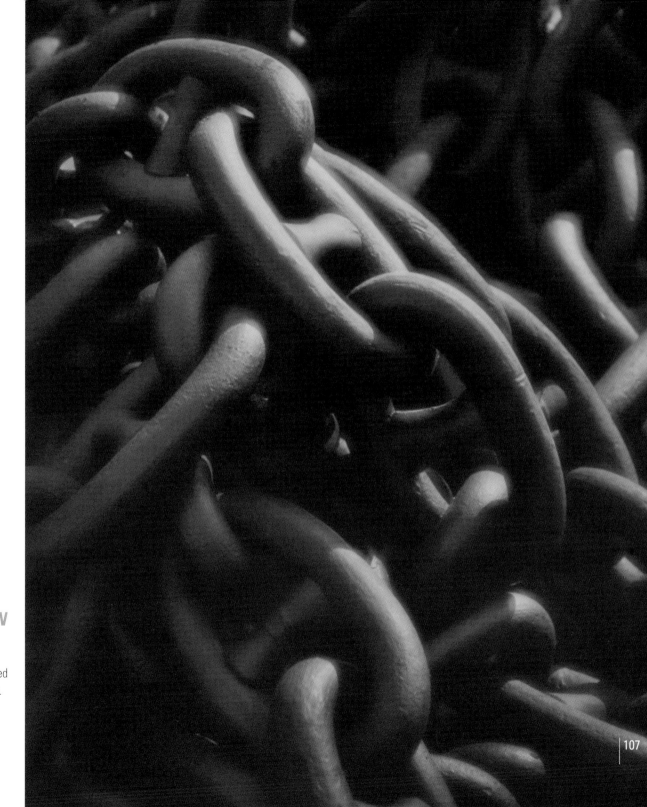

LINKS OF A MAMMOTH CHAIN

One of a number of photographs in which Hardman represented works of engineering as if they were pieces of abstract sculpture.

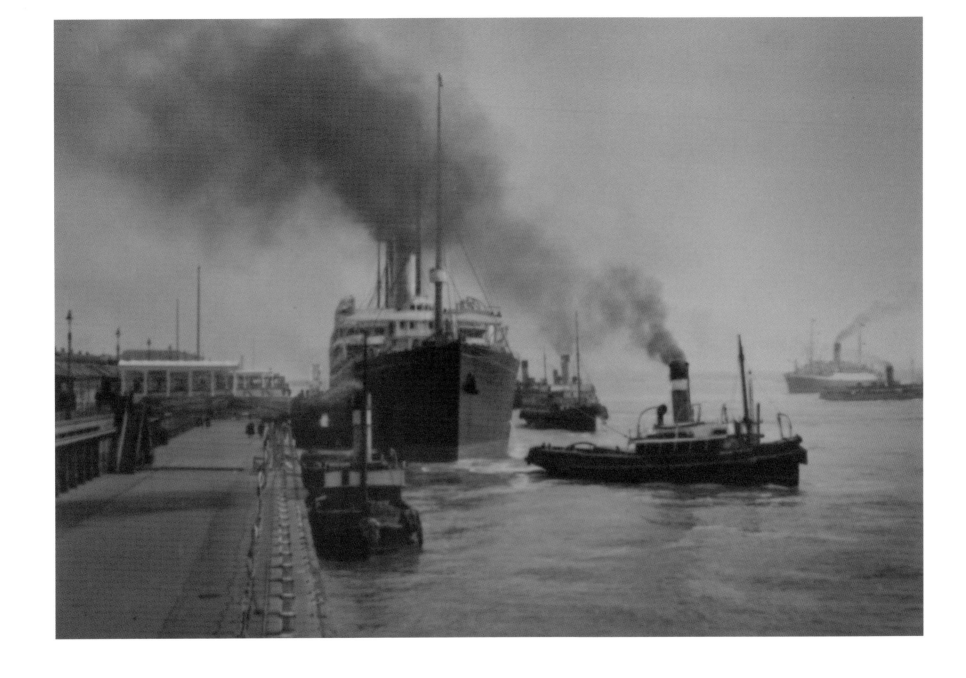

**TUGS PULLING SHIP OUT,
PIER HEAD** The ship is shown leaving the landing stage, the huge floating platform moored at the Pier Head that rises and falls with the tide.

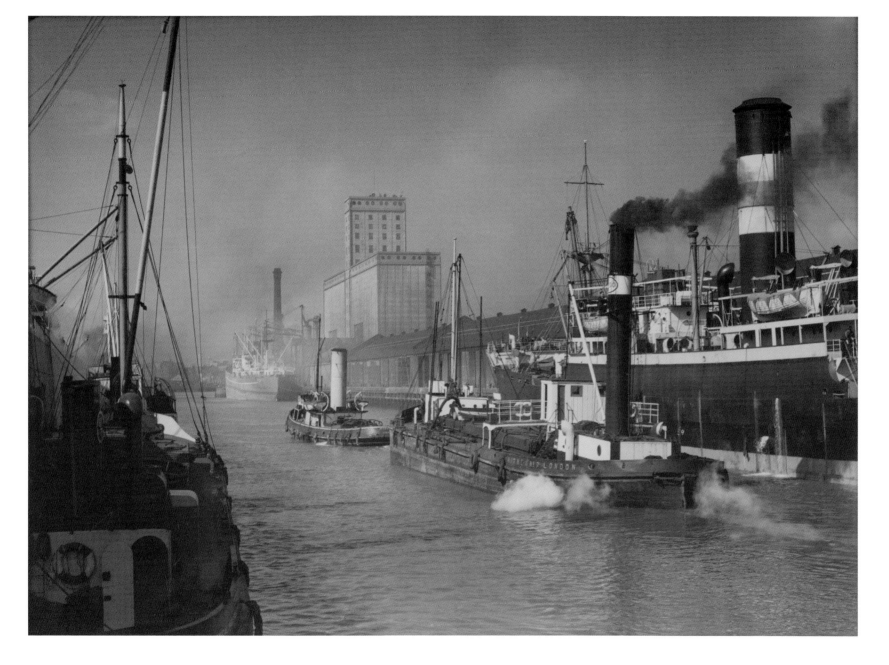

BRUNSWICK DOCK WITH TUGS

In the centre of this view, dominating the landward side of the dock, is the huge concrete granary erected in 1935–37 by the Liverpool Grain Storage and Transit Company. Despite being targeted by the German air force, it survived the Second World War and continued in use until the early 1980s. It was eventually demolished in about 1989, as the redundant south docks were redeveloped for residential, leisure and office uses.

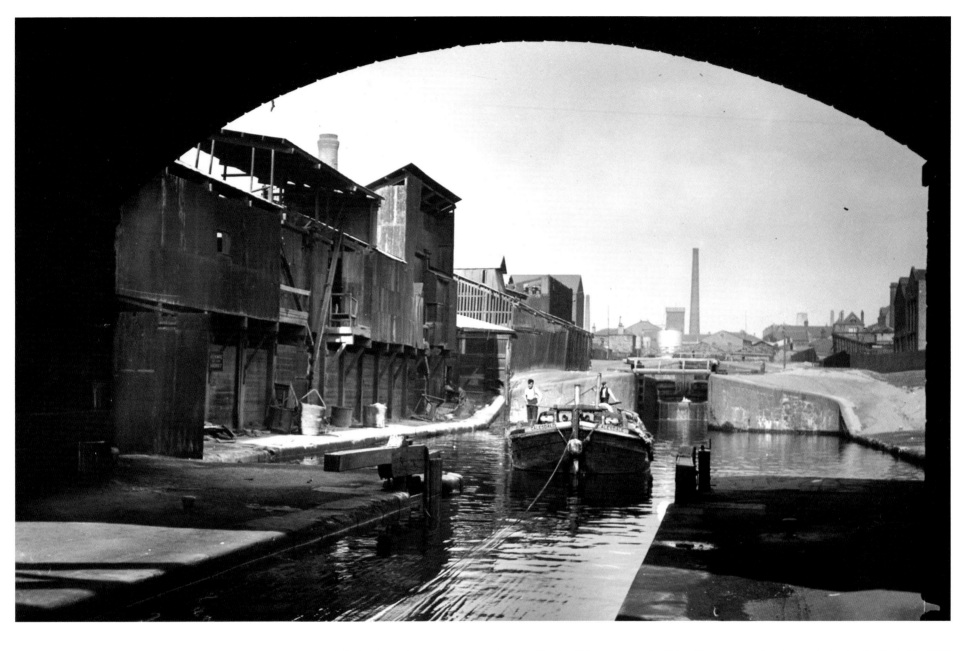

BARGE ON THE LEEDS AND LIVERPOOL CANAL

Polluting industries grew up along the canal in the 19th century, providing employment but also blighting a large district north of the city centre. Hardman's photograph captures the squalor of this industrial area as it declined in the mid-20th century. Framed in an arch of the railway viaduct which leads to Exchange Station, it shows the flight of locks connecting the canal with Stanley Dock. The 1927 Ordnance Survey map identifies the buildings on the left as a bone manure works and a refuse destructor, those on the right as a wool disinfecting station. The scene is very different today: the canal is used for leisure purposes, and runs between landscaped banks.

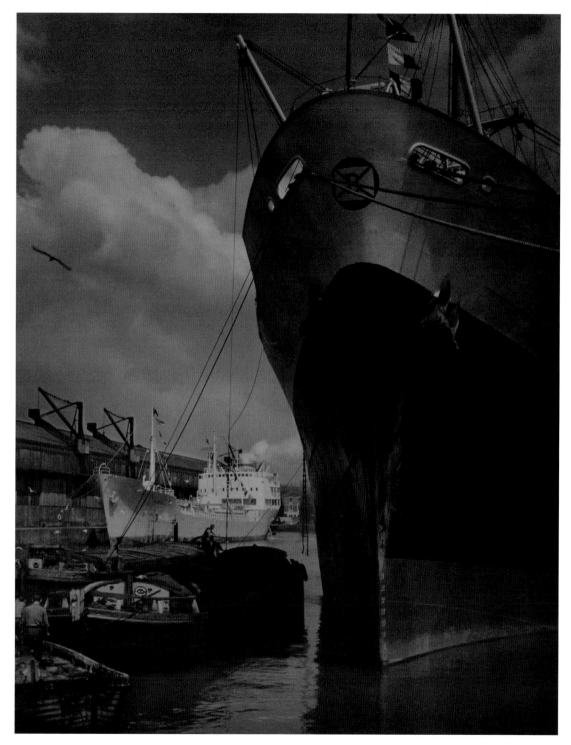

SS HUBERT IN QUEEN'S DOCK

Many of Hardman's photographs of shipping were taken in the same stretch of the south docks – Coburg Dock, Brunswick Dock or, as here, Queen's Dock. The area was just a quarter of an hour's walk from where he lived in Hope Street in the 1930s, and later in Rodney Street from 1949.

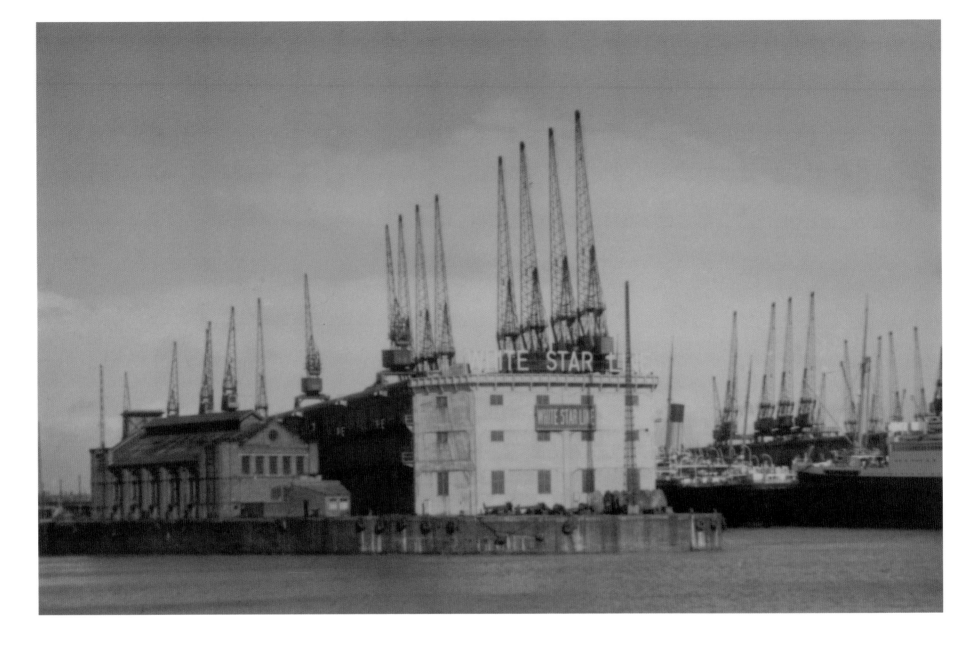

WHITE STAR LINE CRANES

This shows the White Star Line's berth in one of Liverpool's north docks. Evidently no cargo was being moved when Hardman took the photograph, and the ranks of cranes stand at ease, pointing skywards. The White Star Line, founded by Thomas Henry Ismay in 1869 as the Oceanic Steam Navigation Company, was one of the leading names in transatlantic shipping, its most famous vessel being the ill-fated *Titanic*. The Line's former headquarters still stand in the centre of Liverpool, close to the waterfront at the corner of James Street and the Strand (see page 64).

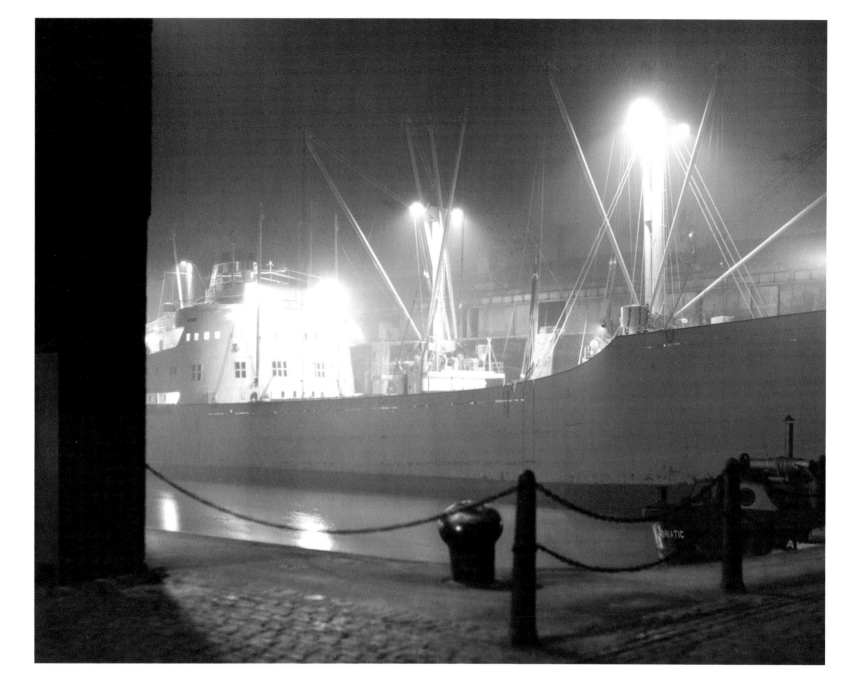

FREIGHTER IN DOCK AT NIGHT A common enough dockland sight during the day, the freighter takes on an almost otherworldly character at night.

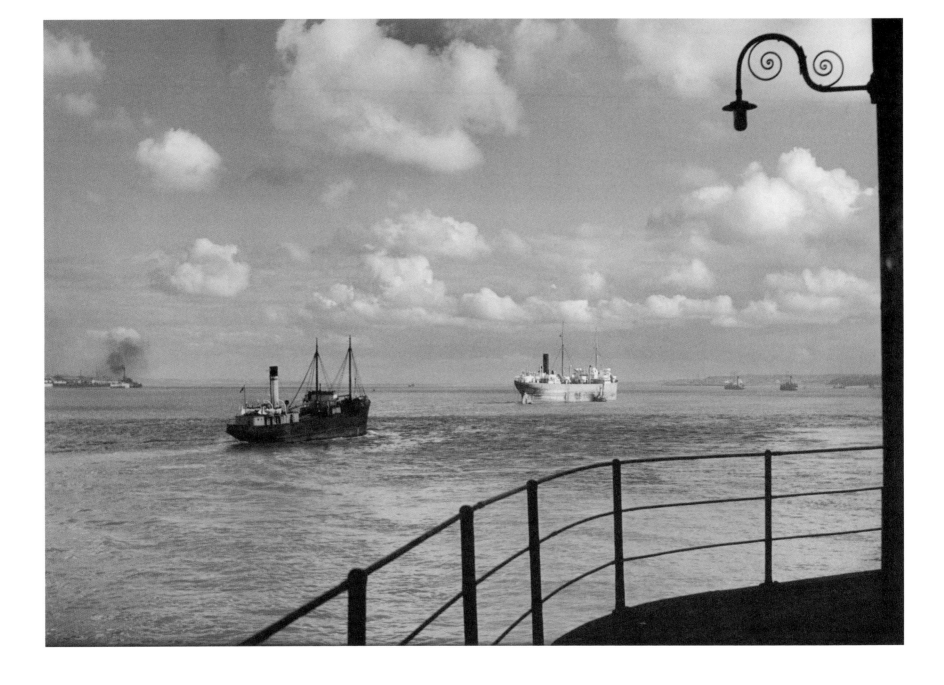

**DECEMBER SUNSHINE
1946**

This winter view of the Mersey is one of many of Hardman's photographs of local subjects that were published in the *Liverpool Daily Post*. It appeared on 28 December 1946.

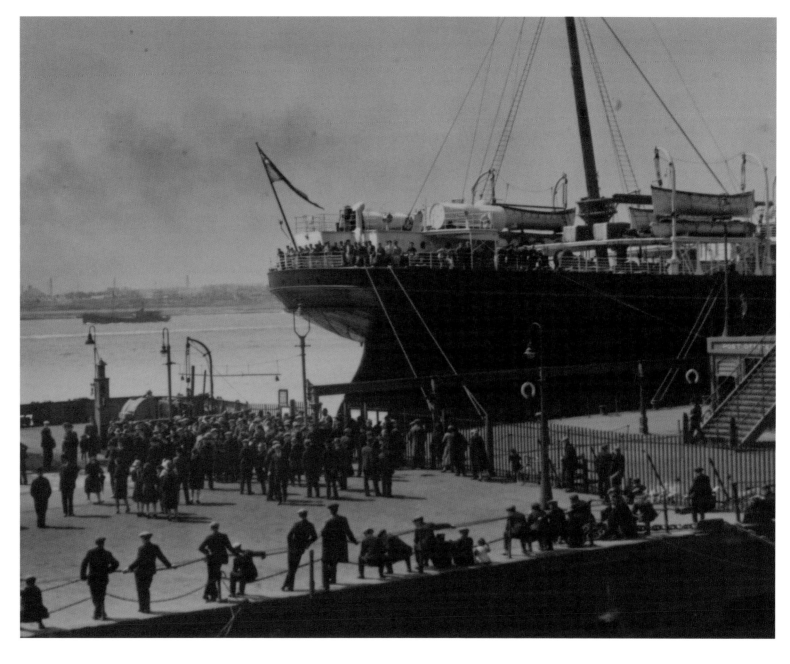

SHIP DEPARTING 1956

The location is the Prince's Landing Stage at the Pier Head. It is a splendid setting for celebrating the comings and goings of ocean liners, but on this occasion only a small crowd has gathered to watch the big ship slip her moorings. Until recently this was thought to show the Canadian Pacific liner *Empress of Britain*, departing on her maiden voyage from Liverpool to Montreal on 20 April 1956. Doubt has now been cast on this identification.

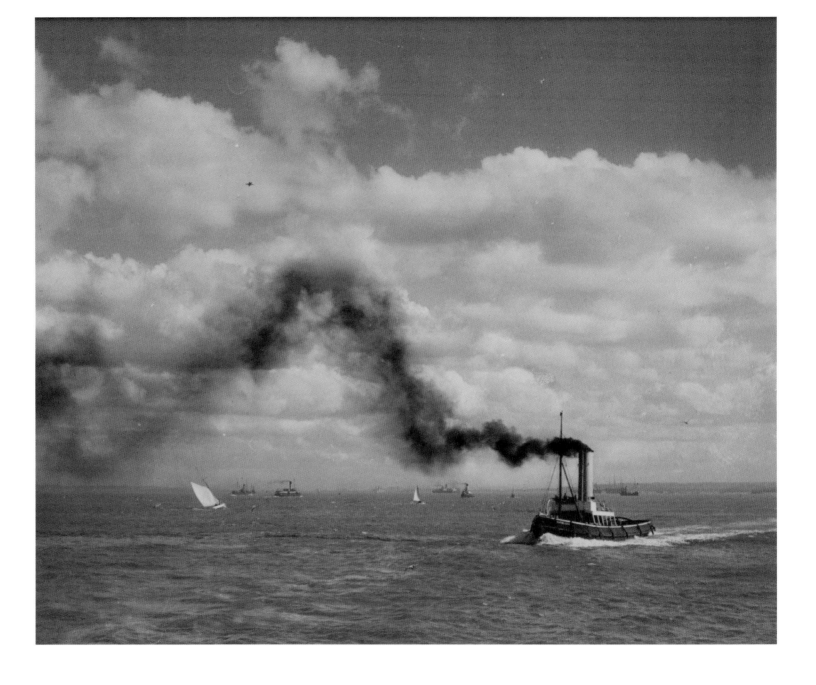

TUG ON THE MERSEY Black smoke pours from the funnel of this small vessel, which seems even smaller against the broad expanse of the Mersey.

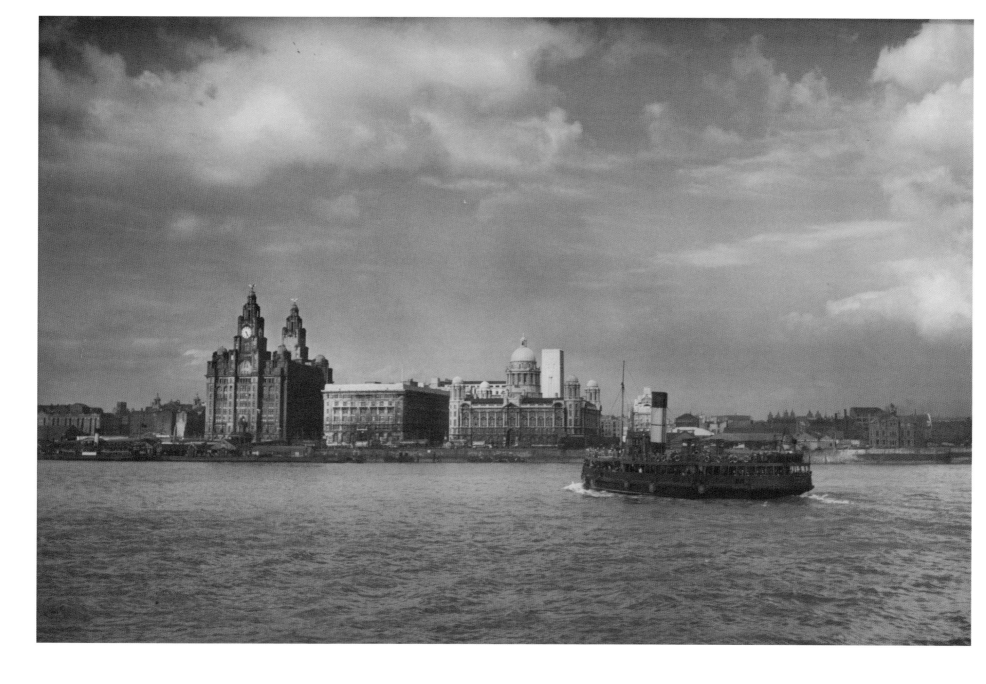

FERRY APPROACHING LIVERPOOL Hardman took this view from Birkenhead. It was published on the front cover of *Canada's Weekly* in October 1946, in an issue entitled 'Liverpool – Gateway to the West' – an instance of the Pier Head being used as an internationally recognisable symbol of the city.

EVENING ON THE MERSEY
1967

Dominating the Birkenhead waterfront on the far side of the river is the distinctive shape of one of the ventilating towers of the first Mersey road tunnel, Queensway.

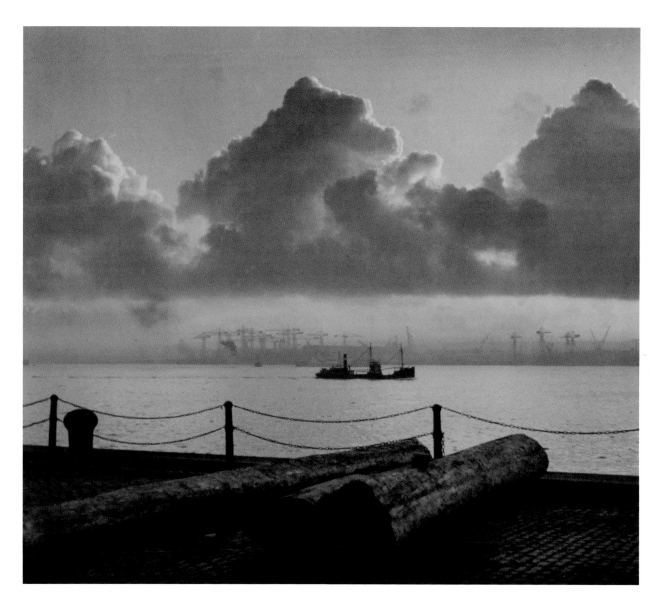

THREE LOGS AND THREE CLOUDS
1960

Hardman's eye was drawn to the kind of visual 'rhyming' seen here, the three heavy logs on the quayside echoing the three distinctive peaks of dark cloud above. The location is near Duke's Dock, just south of Albert Dock. Across the river are the cranes of Cammell Laird's shipyard.

THE COCKLE HOLE
1958

The viewer has to look closely to recognise this as a Liverpool scene at all. Hardman later described the location (South Ferry Basin, constructed c. 1817–23 for ferries and fishermen) in one of his notebooks: 'Close to the Coburg Dock is this little inlet which provides anchorage for some dozen small fishing vessels. It has no dock gate and is open to the Mersey. The spontaneity of this picture is due to my not allowing the figures to see me or my camera. The man nearest the camera is actually mending a net, and apart from Cammell Laird's cranes across the river, the scene might almost have been taken in Cornwall.'

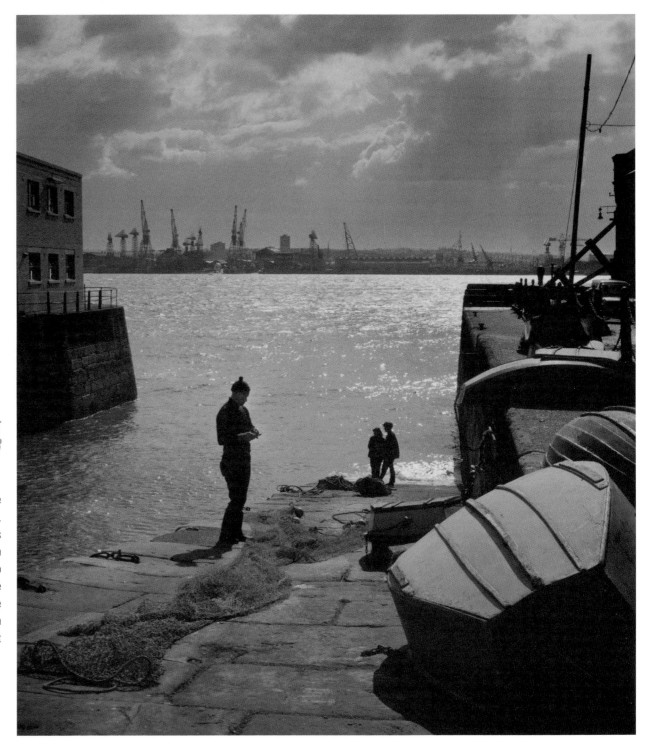

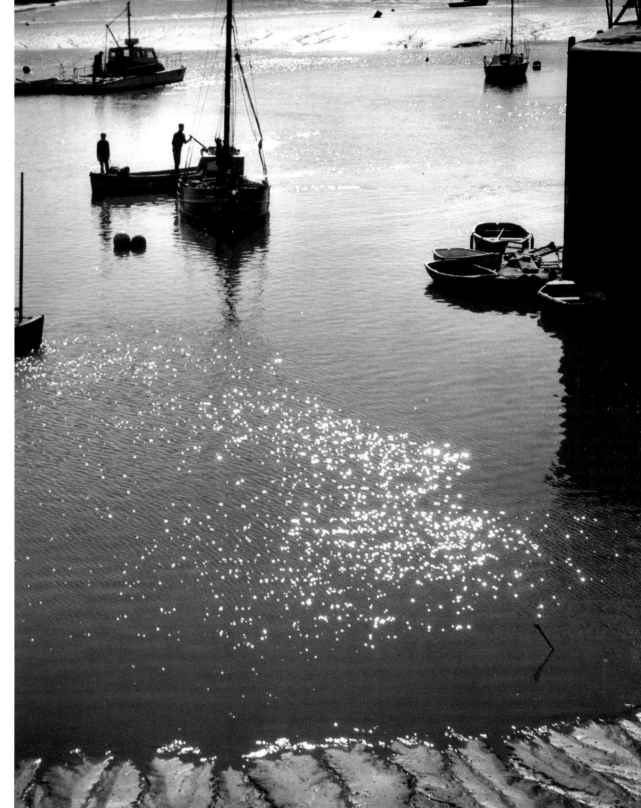

FISHING BOATS AT LOW WATER
1978

This recalls Hardman's photograph of the Cockle Hole, taken twenty years earlier (see opposite). The small vessels and sunlit water make the silted-up Coburg Dock look like a scenic fishing harbour.

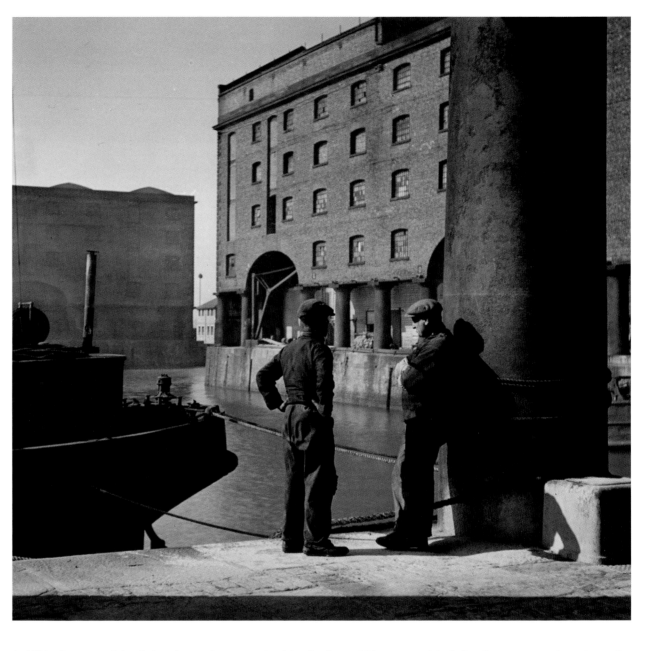

STEVEDORES, ALBERT DOCK
1945

In 1984, after years of dereliction, the warehouses on the right of this view were transformed into the Merseyside Maritime Museum, while those in shadow on the far side of the dock were converted to house the Liverpool outpost of the Tate Gallery. In adapting them to these new uses the buildings were carefully restored, and some later additions removed, including the extra storey above the cornice of the block on the right. The arches at quay level were originally designed to allow cranes to swing in and out when unloading ships: one of these cranes is visible, just above the shoulder of the stevedore on the left.

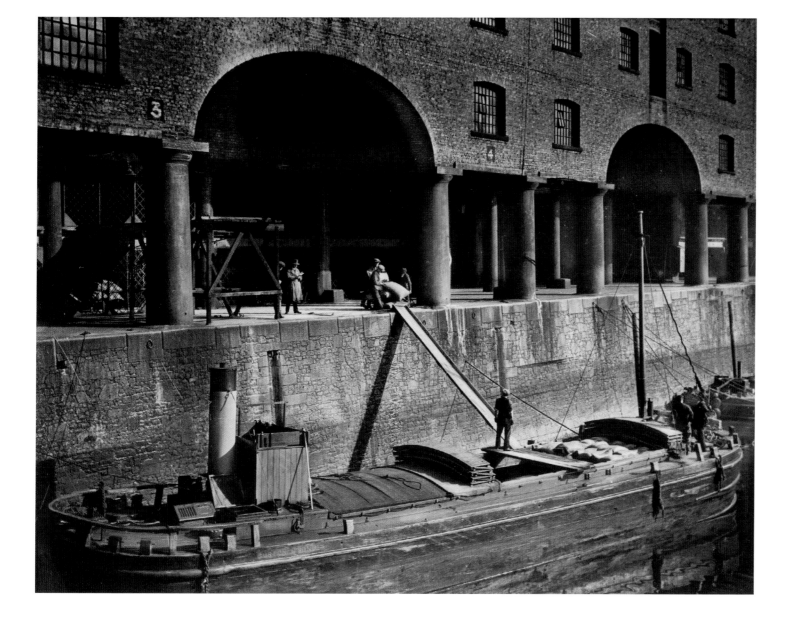

LOADING GRAIN, ALBERT DOCK
c. 1931

This photograph evokes the original industrial character of Albert Dock, quite different from its sanitised appearance after restoration as a tourist destination in the 1980s. It shows the massive strength and solidity of the structure: the squat cast-iron columns, the immensely thick brick walls, and the irregular jigsaw of 'cyclopean' granite – the engineer Jesse Hartley's trademark – that makes up the dock wall. Buildings for storing flammable merchandise such as spirits, oil and cotton were particularly at risk from fire, so the Albert Dock warehouses were designed to be completely fireproof. No combustible materials were used in their construction, and the original window frames, like the columns, were of cast iron.

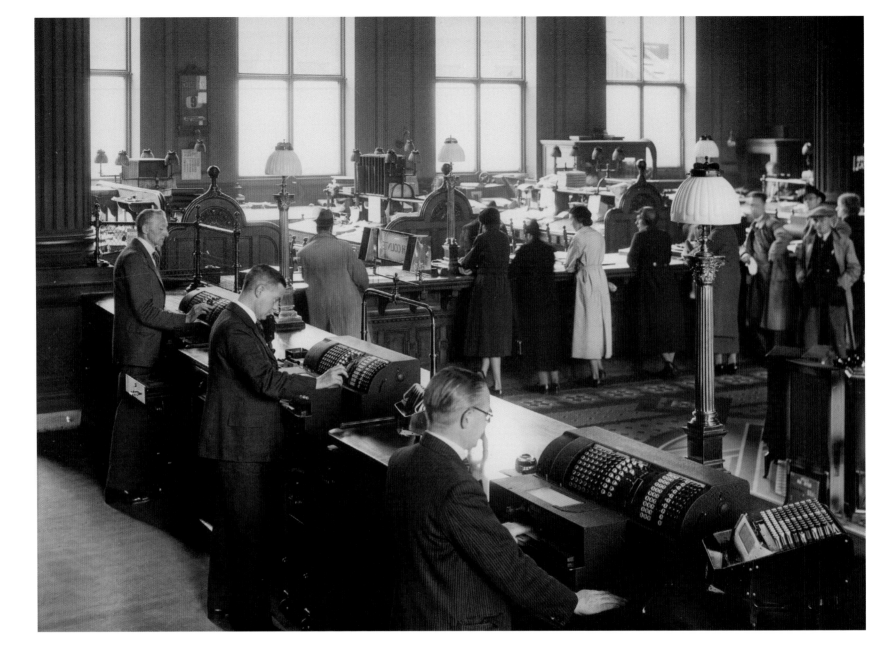

LIVERPOOL GAS COMPANY
1936

This appears to be the public office of the Liverpool Gas Company's headquarters in Duke Street, between Kent Street and Cornwallis Street. Opened in 1872, the building was designed by Charles Lucy and Henry Littler. Two years after Hardman took this photograph the Liverpool Gas Company opened brand new headquarters at Radiant House in Bold Street, and the Duke Street building was later demolished.

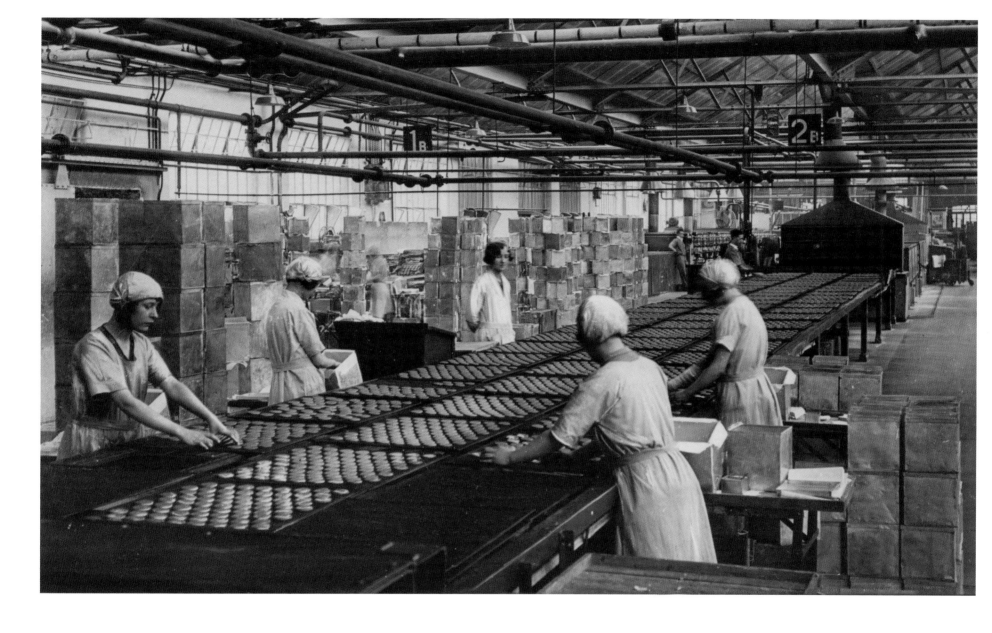

WORKING ON THE CONVEYOR BELT, JACOB'S FACTORY 1930–32

Historically, many of Liverpool's industries were based on processing raw materials brought in through the docks. Raw sugar and wheat imports encouraged flour milling and sugar refining, which in turn led to biscuit production on a large scale. Hardman was commissioned to take a series of photographs of Jacob's biscuit factory at Aintree around 1930. As well as the production line he recorded the factory's social provision for workers, which included a swimming pool and tennis courts..

CLAY AND ABRAHAM

Clay and Abraham's chemist's shop was at 87 Bold Street, a few doors above the studio occupied by Hardman before his 1949 move to Rodney Street. In 1921 Charles Reilly described its attractive frontage as 'the small but highly discreet shop front of Messrs. Clay and Abraham's, in red and gold, surmounted appropriately enough by a finely carved Royal Arms'. According to Reilly, it had 'just the right reserve for a chemist who really deals in medicines. With such an appearance alone, one could have absolute confidence that one's prescriptions would be correctly made up, and what more does one want?'

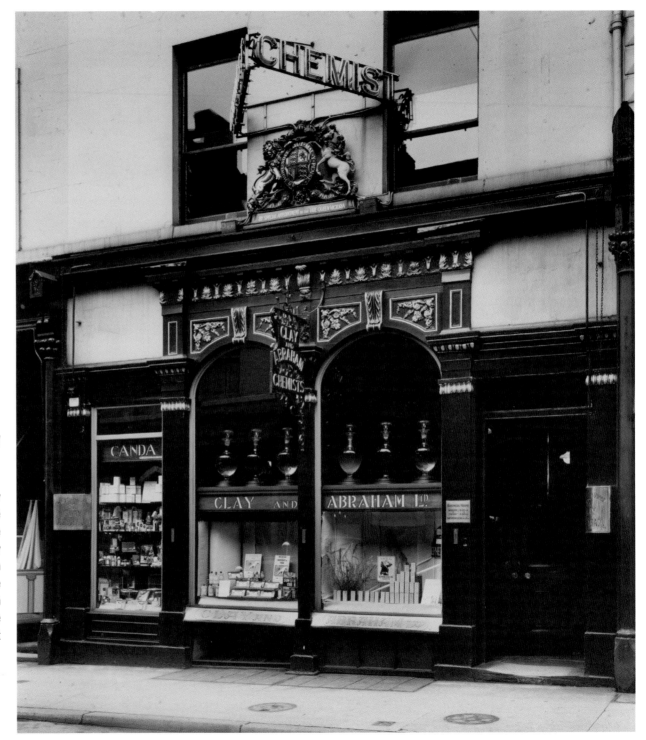

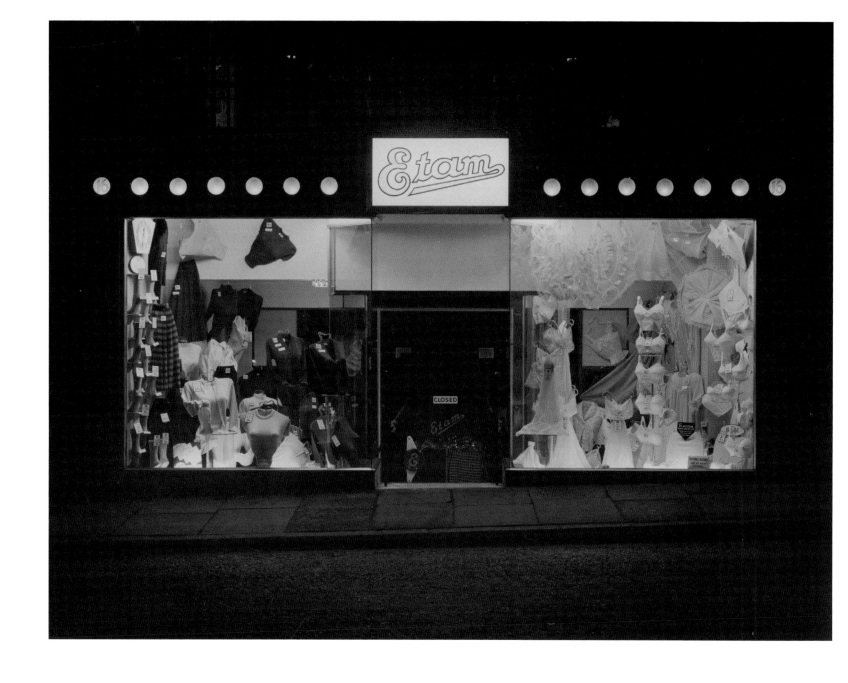

ETAM SHOP WINDOW 1950s This high street chain of 'ladies' hosiers' had shops in Church Street and Clayton Square in the 1950s.

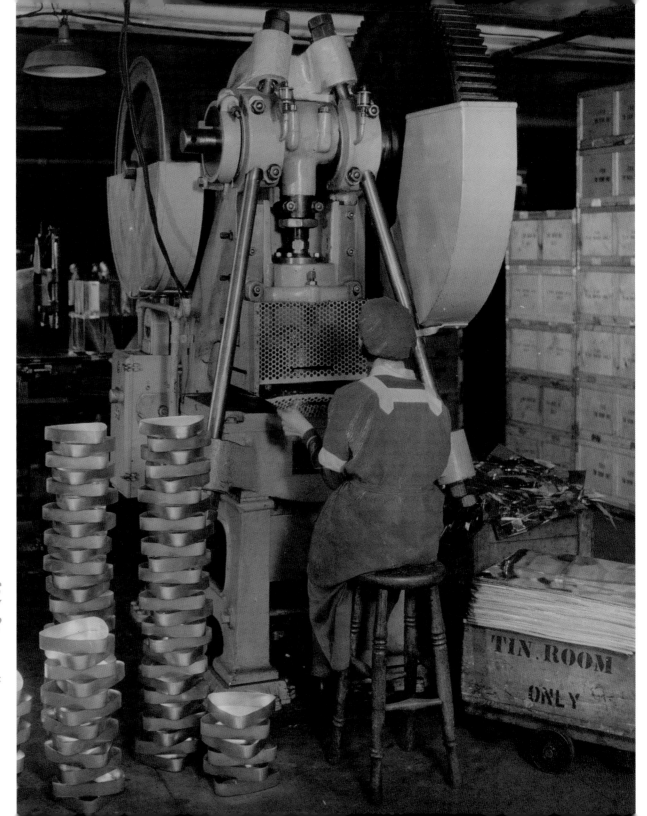

MAKING BISCUIT TINS, JACOB'S FACTORY
1930–32

Hardman used Jacob's biscuit tins to store his photographic negatives: by the 1970s the collection filled 307 tins.

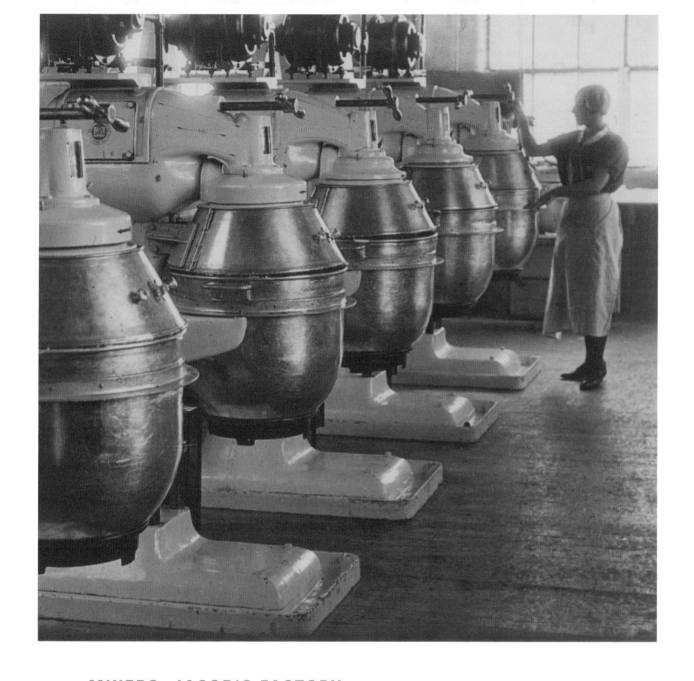

MIXERS, JACOB'S FACTORY
1930–32 These machines were used for producing marshmallows.

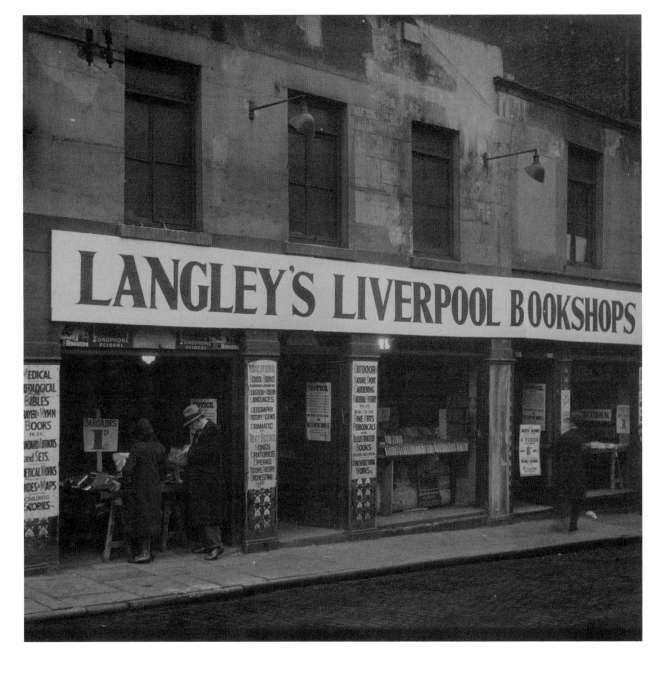

LANGLEY'S LIVERPOOL BOOKSHOPS

This undated photograph probably shows Upper Dawson Street, where Langley's had premises in the 1930s. A short and rather shabby street between Williamson Square and St John's Market, it was home to a number of second hand bookshops. It was swept away along with the market when the St John's Precinct shopping centre was built in the 1960s.

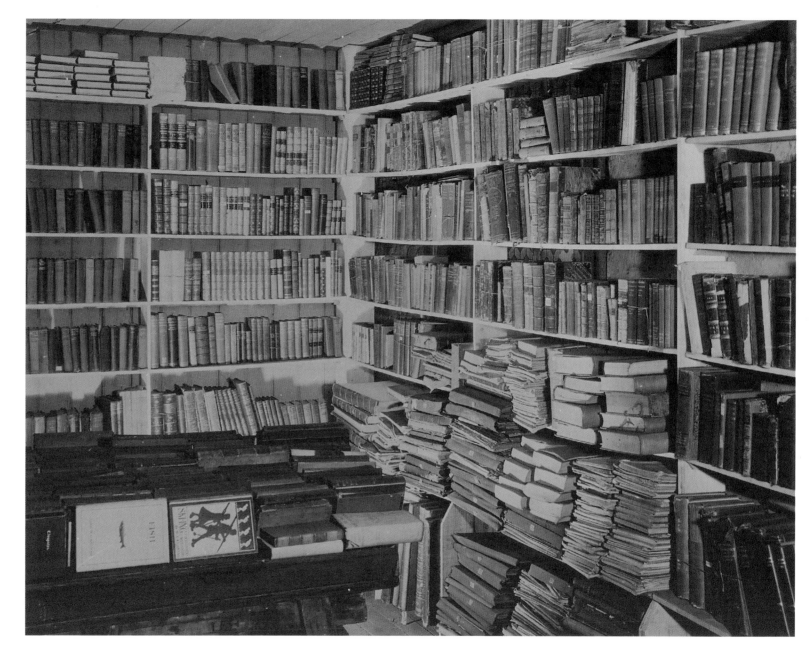

LANGLEY'S LIVERPOOL BOOKSHOPS INTERIOR 1933

This may be the interior of Langley's shop in Upper Dawson Street, Liverpool (see opposite), though the firm also had a shop in Chester.

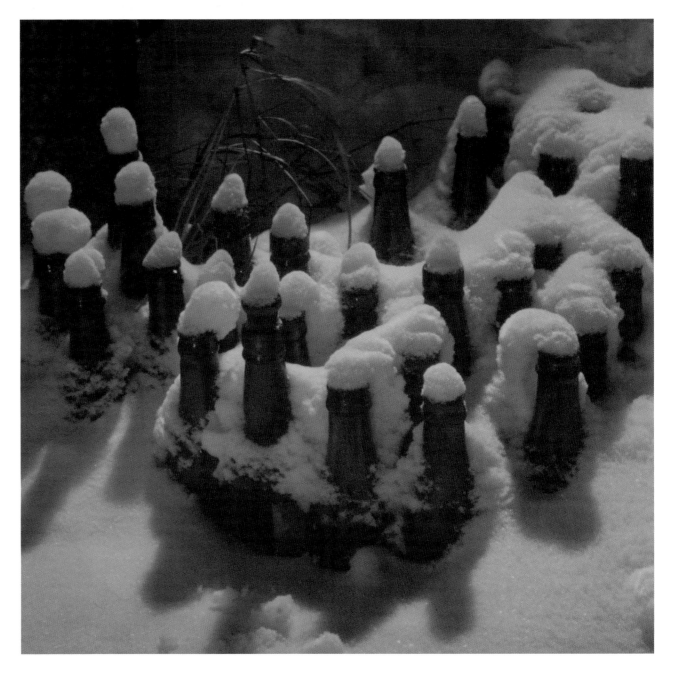

BOTTLES IN THE SNOW
1944

One of Hardman's witty shots of a quirky subject spotted by chance: snow transforms the empty bottles, so that they seem to be overflowing with foaming beer.

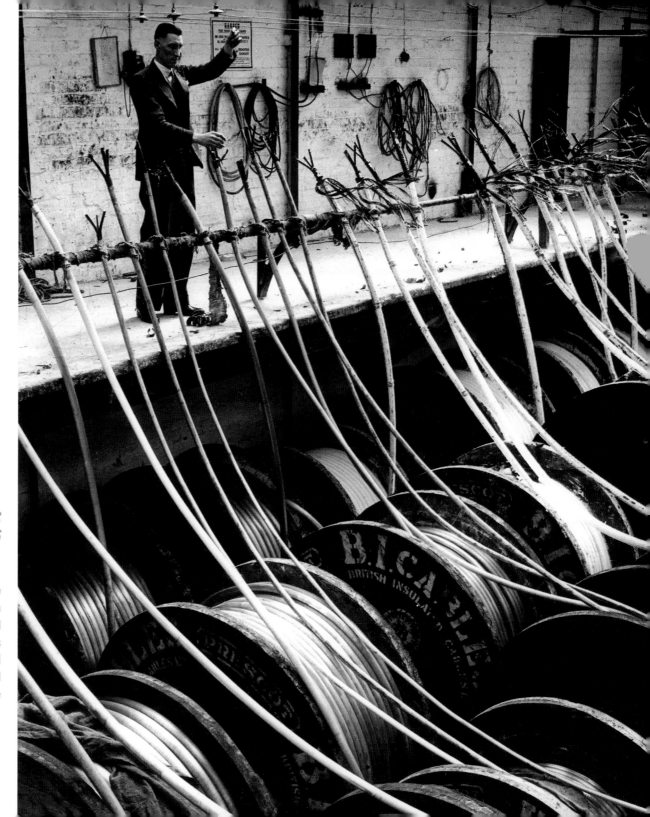

TESTING CABLES
1936

One of many photographs commissioned from Hardman in the 1930s by British Insulated Cables Ltd. The Prescot-based firm was a pioneer in the manufacture of electrical cables. In 1945 it merged with Callenders of Firth to become British Insulated Callenders Cables, better known today as BICC. Hardman photographed clerical work in the company's offices as well as buildings and storage areas, but his most striking images record aspects of the manufacturing process.

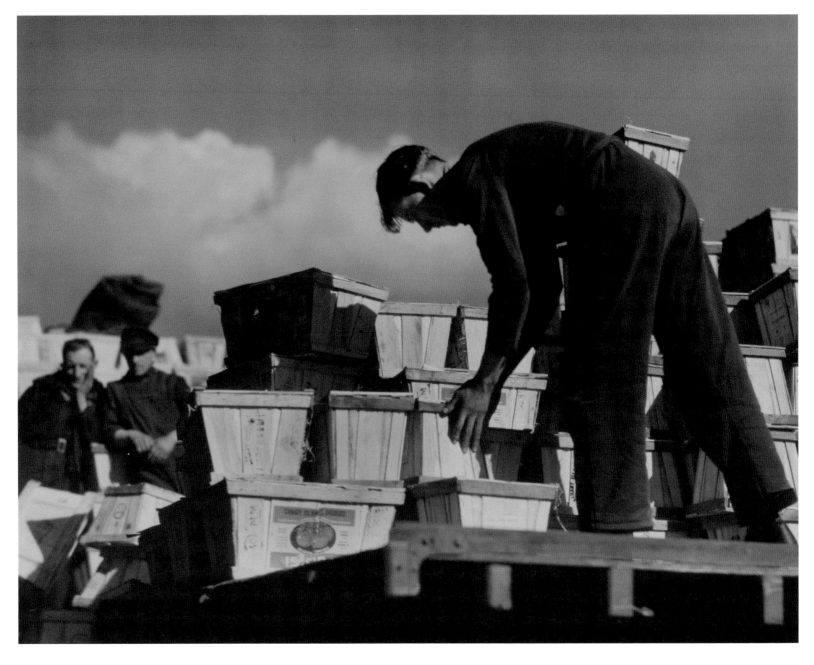

A scene of cargo handling at the Liverpool docks, though as is often the case with Hardman, he seems to have been more interested in creating a satisfying composition than in capturing the bustle of what was no doubt a busy scene. The main figure looks static, as if carefully maintaining a pose he has been asked to assume. His strong, dark shape, silhouetted against the bright sky and sunlit boxes, is the focus of the picture.

STACKING TOMATO BOXES

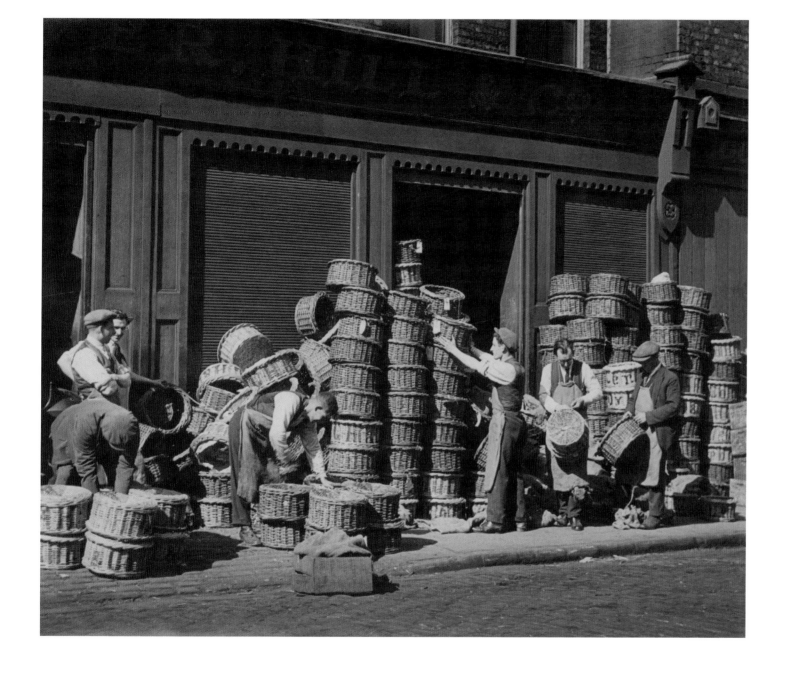

Glover, Hill & Co. were fruit merchants. In the 1930s their premises were at 11–15 Great Nelson Street, near what was then the wholesale fruit and vegetable market, off Scotland Road. The men in Hardman's photograph are presumably stacking empty baskets at the end of the day's business.

GLOVER, HILL & CO

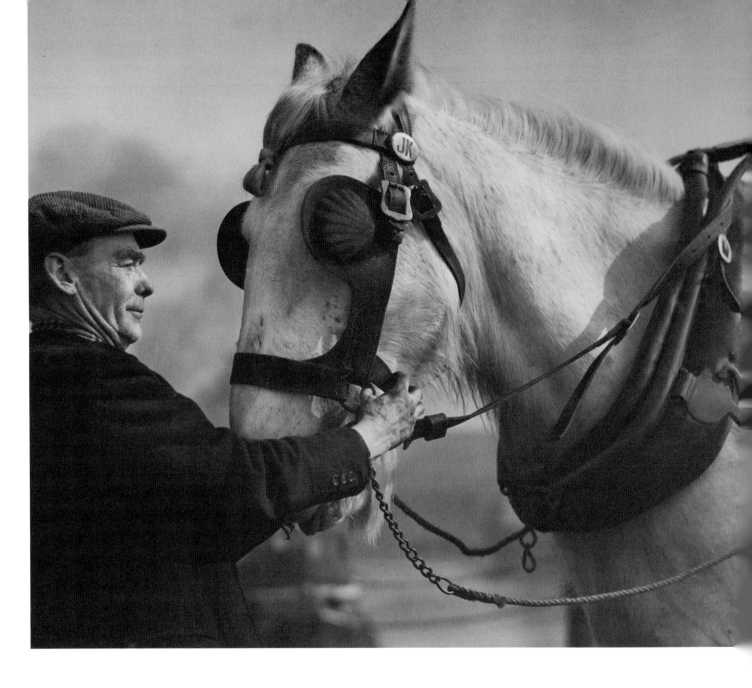

**CARTER AT THE DOCKS
1946** Horse-drawn carts continued to be used at the docks until well into the 20th century. Liverpool's draught horses were famous, and were fêted in the city's annual May procession.

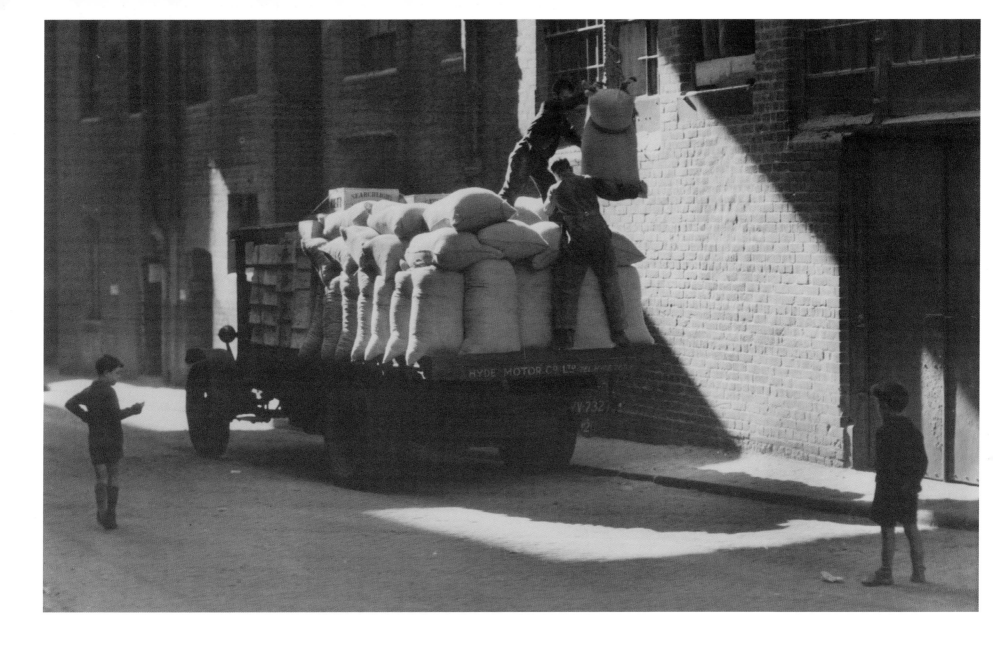

LOADING A HYDE MOTOR COMPANY LORRY 1930s

This image shows merchandise being moved in the warehouse region of Little Howard Street, near its junction with Love Lane.

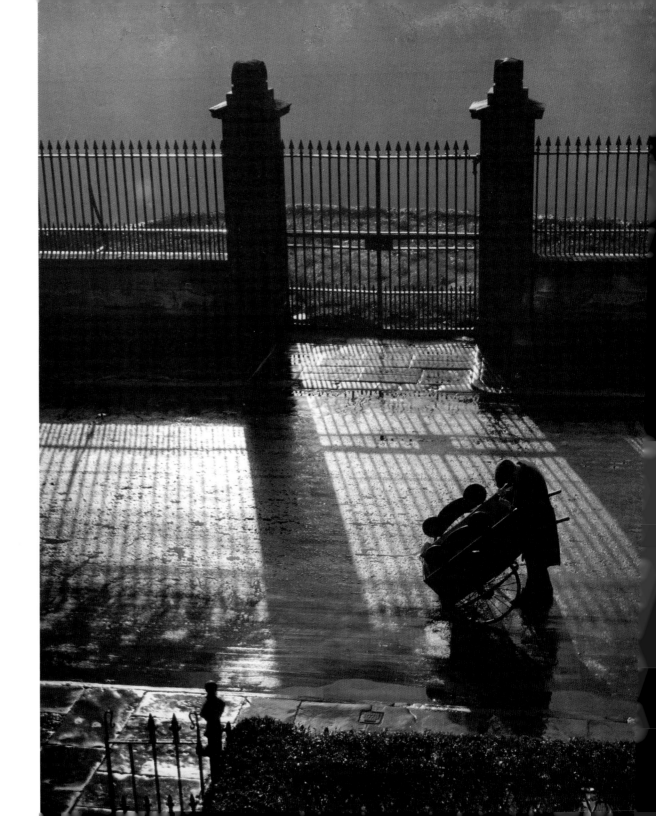

BARROW BOY STOPS FOR A LIGHT
1934

This was taken from a second-floor window of the flat where the Hardmans were then living, at number 53 Hope Street. The once affluent houses of Liverpool's Georgian streets had by this date come down in the world. Beyond the 19th-century railings – taken for scrap during the Second World War, and later replaced with modern ones – is the leafy chasm of St James's Cemetery, and beyond that, though not visible in this shot, the Anglican Cathedral. What might have been a melancholy image, hinting at poverty, decay and even death, is made splendid by the light of the setting sun streaming across the road.

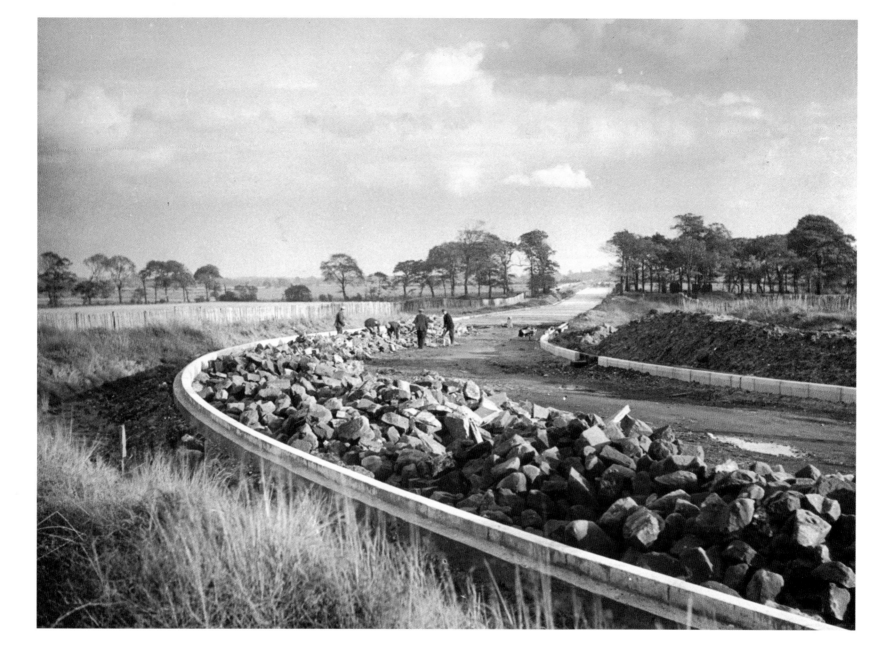

GATEACRE, ROAD CONSTRUCTION
1931

Great changes took place on the rural fringes of Liverpool in the 1930s, as large-scale housing developments and new roads spread beyond the city's former boundaries. This photograph of road building is said to show a scene at Gateacre.

Working to save and protect our coast, countryside, historic buildings and gardens forever, for everyone

Established in 1895, the Trust protects an estate of more than 248,000 hectares of land, some 20,000 vernacular buildings (including almost 200 houses of historical interest), over 200 gardens and landscape parks, and over 700 miles of coastline.

The National Trust aims to sustain local traditions and provide education, enjoyment and a warm welcome to an ever-widening community. Whether you are a member of the Trust, or not, you can contribute directly to the funding of vital conservation work. Please help the National Trust by becoming one of its much valued supporters. There are many ways to support the National Trust, from volunteering and visiting to becoming a member or remembering the Trust in your will.

For more information, please visit www.nationaltrust.org.uk or phone: 0870 458 4000

Mr Hardman's Photographic Studio
59 Rodney Street, Liverpool L1 9EX

Situated just below the Anglican Cathedral in the centre of Liverpool, this fascinating house was home to Edward Chambré Hardman and his wife Margaret between 1947 and 1988. 59 Rodney Street is the only known British photographic studio of the mid-20th century where the photographer's entire output has been preserved intact. The photographic practice, with all the necessary technical equipment, the business records and public rooms, together with the chaotic private quarters, can all be seen beside the wonderful photographic images with all the ephemera of post-war daily life. The subject matter of the photographs – portraits of the people in Liverpool, their city and the landscapes of the surrounding countryside – provide a record of a more prosperous time when Liverpool was the gateway to the British Empire and the world. Parallel to this is the quality of Hardman's work and his standing as a pictorial photographer.

Rodney Street is named after Admiral George Rodney, victor at the Battle of Les Saintes in 1782. Building work began the following year and continued for several decades. It has long been regarded as one of the most prestigious addresses in Liverpool. The street was occupied initially by merchants and increasingly, in the 19th century, by doctors and consultants. The Victorian prime minister W.E. Gladstone was born at No.62.

More information on how to visit is available from www.nationaltrust.org.uk or by calling 0151 709 6261. Admission by guided tour. The house is open to the public between March and October, Wednesday to Sunday.